INTIMATE

AN AMERICAN FAMILY PHOTO ALBUM

THE TUPELO PRESS LINEAGE SERIES

Kazim Ali

Fasting for Ramadan: Notes from a Spiritual Practice

Paisley Rekdal

Intimate: An American Family Photo Album

Ilya Kaminsky and Katherine Towler, editors

A God in the House: Poets Talk About Faith

INTIMATE

AN AMERICAN FAMILY PHOTO ALBUM

Paisley Rekdal

Tupelo Press
North Adams, Massachusetts

Intimate: An American Family Photo Album
Copyright 2011 Paisley Rekdal. All rights reserved.

Library of Congress Cataloging-in-Publication Data
Rekdal, Paisley.
An American family photo album / Paisley Rekdal. -- 1st ed.
p. cm. -- (The Tupelo Press lineage series)
ISBN 978-1-936797-08-0 (hardcover : alk. paper) -- ISBN 978-1-932195-96-5 (pbk. : alk. paper)
1. Rekdal, Paisley. 2. Curtis, Edward S., 1868-1952. 3. Upshaw, Alexander B.
4. Chinese Americans--Biography. 5. Indians of North America--History. I. Title.
PS3568.E54Z46 2011
818'.54--dc23
[B]
2011035705

Cover and text designed by Josef Beery.
Cover photograph / art: "Waíhusiwa, a Zuñi Kyáqïmâssi" by Edward S. Curtis,
from *The North American Indian*, Volume XVII.

First edition: April 2012.

Tupelo Press
P.O. Box 1767
243 Union Street, Eclipse Mill, Loft 305
North Adams, Massachusetts 01247
Telephone: (413) 664–9611 / Fax: (413) 664–9711
editor@tupelopress.org / www.tupelopress.org

Tupelo Press is an award-winning independent literary press that publishes fine fiction,
nonfiction, and poetry in books that are a joy to hold as well as read. Tupelo Press is a registered
501(c)3 non-profit organization, and we rely on public support to carry out our mission of
publishing extraordinary work that may be outside the realm of large commercial publishers.
Financial donations are welcome and are tax deductible.

For my parents, for their patience and their love.

THE PHOTOS ARE BY THE BED. Edward Curtis's first volume of THE NORTH AMERICAN INDIAN: My father had laid the book on his night table beside a box of pills, an extra pair of glasses, and the novel by Conrad I'd bought for his birthday. I am at my parents' house alone, while my father is at the hospital with my mother, who is being prepped for an operation for her cancer. The fact that my mother has gone to the hospital at all and discovered this cancer is surprising: She has avoided doctors since my father's operation years ago on a tumor in his neck. She still talks about the smells there, the awfulness of his room, the way his attending nurse scrutinized her Chinese face when they first met, then looked over at my white father and at me, their child, and asked me, *Are you the translator?*

I pick up the book and open its pages. The thick sepias and golds, the creamy whites. I am struck by the faces inside, shapes that in their gauzy haze appear both dreamlike and documentary. Here are portraits of warriors and maidens, shamans, chiefs, even a Hamatsa transforming himself into a flesh-eating spirit, with dried fern fronds curled in his hair.

I had been reading books about photographers of the American West for a series of poems I was writing, and I had mentioned this to my father. In particular, I'd become interested in one of Curtis's guides, an Apsaroke named Alexander Upshaw, about whom only the vaguest details are known. I was interested in constructing a biography of him.

Though my father hasn't told me, I know his sudden interest in Curtis has been sparked by my research. It was always like this, my father asking what I liked and then purchasing a copy of something comparable for himself. There is even a recent credit card receipt for the book with my father's name and number tucked into the jacket. I turn the pages of my father's book. On the last page is Chief Sealth's daughter, Angeline, taken twenty years after her father's death. Here is her small frame bent beside the canoe: a dark, stooped shape by light-sequined water in the Sound, beside which she almost disappears. While the water and sand, beneath her, shine.

Behind this book on his night table, there is a honeymoon photo of my mother and father, the glass frame slightly fissured, so that when the winter sun travels across its surface, one or the other of my parents' faces looks scratched out with light.

Staring at the book, I forget why I used to dismiss Curtis. I'd known that he posed and sometimes even faked his shots, that he accentuated his subjects' foreignness by putting them in other-worldly costumes and settings: covering up the missing pieces of the narrative. Now I realize I hadn't seen the narrative. All the time it had surrounded me: I'd grown up in Seattle where Curtis had lived; I'd walked past a copy of the Angeline photo in Ivar's Restaurant, indifferent to the velvety gold in each scallop of water, her small shape against the once-deserted shoreline. I had seen all these photos before in the museums and school hallways of my childhood and overlooked them. The darkened, mythic features that faded into light. Perhaps I had not been interested enough to look. Or: perhaps I had not allowed myself to take an interest.

Beside their honeymoon photo, there are pamphlets the hospital has given my parents. A precautionary measure, the doctors told us. A series of questionnaires and workbooks to be filled out. CHOOSING YOUR END QUALITY OF LIFE.

I take out the receipt from my father's book, tuck it back. On my mother's nightstand is a box of chocolates and a photo of our family.

On my table at home are volumes of American Indian photographs, snapshots taken by ethnographers and anthropologists and census takers with their footnoted evidence—the drier histories I'd have thought my father would prefer. Holding my father's volume of Curtis's photographs, I wonder for a moment if we have switched places: my father at home studying these romantic, Pictorialist tableaux, myself reconstructing biographical facts. And between these strands of sight—one documentary, one poetic—I imagine that a conversation might occur, the images blending together, complementing, then arguing against each other.

I think of the essay I want to write. There is a portrait of Alexander Upshaw, too, among Curtis's photos. I flip the pages, trying to find him. I hold my father's book in my hands. Something blank and invented, something fabulous and real. I look and look at the photographs.

The photos look back at me.

I

Mr. Edward Curtis . . . has been able to do what no other man
has ever done; what, as far as we can see, no other man could
do. He is a close observer, whose qualities of mind and body fit
him to make his observations out in the field, surrounded by
the wild life he commemorates. He has lived on intimate terms
with many different tribes of the mountains and plains . . .
He has not only seen their vigorous outward existence, but
has caught glimpses, such as few white men ever catch, into
that strange spiritual and mental life of theirs; from whose
innermost recesses all white men are forever barred.

THEODORE ROOSEVELT
from the Introduction to Volume One of
THE NORTH AMERICAN INDIAN

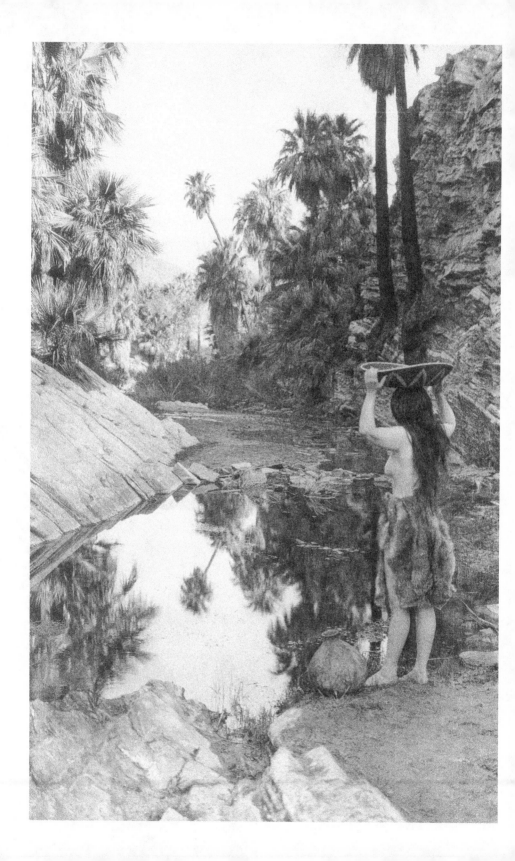

Edward Curtis's
"Before the White Man Came"

It's a paradise, isn't it?

Palm trees, tropical
and lush, small lake glittering by sandstone
before which she stands, stripped

to the waist with its skirt of fur, basket tipped
atop the head like a hat brim. A fall

of hair brushes her buttocks.
She will not turn

her face to us but marks the fresh world
by parallel containments: breast-shaped
vase beside the feet, vase-shaped rock
smoothed out by wind, water; gaze's receptacle

made gorgeous in a skin we'd like to believe

makes time and culture meaningless
geographies. Sun fires the land.
Shadow darkens the armpit.

How easily we say we're moved

by frosts of light, the sky a thin cloud
scrolling overhead that the land
calls down to, beckons back, remakes

this shore we want to see—
its pulsing throat; its clear, untainted waters—

these first imagined forms from which
we declare ourselves
so lost—

Edward Curtis, 1868

Born on a farm near Whitewater, Wisconsin. The second child. The one responsible. The one who invented, the one who made do. His most advanced education is grammar school.

First Camera, Age 12

He fits it out by placing one dark box inside another, a stereopticon lens mounted in the front. The lens itself is scuffed nearly opaque from all its travels, purchased by his father in the Civil War. His father watches from the doorway. Blue work shirt so thin at the neck and buttonholes as to be little more than a wash of color. *That's a useless tool,* he says, pointing at the camera. *What are you going to do with it?* The child shrugs. The child takes apart his father's gadget, reinvents it according to the book propped in front of him, WILSON'S PHOTOGRAPHICS: A SERIES OF LESSONS, ACCOMPANIED BY NOTES, ON ALL PROCESSES WHICH ARE NEEDFUL IN PHOTOGRAPHY. "Remember, photography is a circus kind of business, unfit for a gentleman to engage in." They are not gentlemen. His father shakes his head, limps back from the doorway. *You want to do something with yourself,* he calls back, *learn a trade.* The boy hunches over his reconstructed box. Black wood, brass fittings, one enormous scratched eye. He looks through it. The world, that vague blue mist, looks back at him.

Alexander Upshaw, 1879

Bare wood planks, smell of beeswax thickening the linen, hot water, and steam that beads the warped window. He is alone, as always, with his mother. He's five. He likes watching her pile up her black hair in a knot, the white blouse straining at her shoulders. She speaks to him in English, sings in Crow. *You don't want to be behind if you go to school.* Eye-height to the kitchen table, he watches where she works the white mountain of other men's shirts. He learns by watching from the outside. Quiet tug of his mother's needle, stitching in and out of the linen, piercing the fabric.

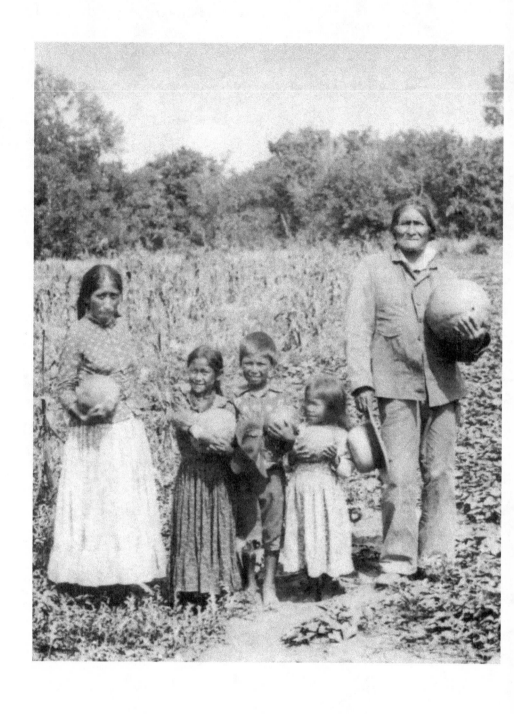

Weevils

With God's grace we might scrape by, Curtis's father says. The boy is out in the field with him, picking maize weevils out of the few surviving rows. A field where once was lushness, but the War came, along with drought, and now insects have come to take the rest. Down the rows, the corn glows green at the tips in morning sunlight, but the boy can see, if he looks down, the long stalks withering at their stems. The boy says, *There are men who have portrait shops in the city.* He picks a few weevils, places them in the basket at his feet. *Not enough money for a family,* his father replies. *Everything's changed; people don't have time for pictures.* He stands and places a hand on his lower back. He drops his handful of weevil grubs on the ground and stubs them out with his boot toe. Light swells in the sky, glows through the faint wisps of the father's hair and the pink skin of his ears until the boy, glancing at his father, imagines this body too is shot with light. Then he looks down, sees his father's dust-spattered pants, the shoes cracked and stuffed with newspaper. His father stands and straightens. Looks at him. *We're finished here,* he tells the boy.

Curtis the Son

Imagine the father: Union soldier, part-time preacher, subsistence farmer. Dark-eyed, his throat all Adam's apple, half a foot shorter than his photographer son. He left for the War, came back knowing everything left is a process of dying. A man haunted by this, the fear that he will lead his family to the county Poor Farm. His back, injured in the War, never properly heals. Days in bed, eyes closed against the ferocity of light, each ray like a bullet entering his pupils. *Turn away that lamp. My eyes. It's burning straight into my eyes.* Thunder in the long fields: the sound of cannon fire. Soft mouth, white scar. *Everything's changed and what do we have to live on for?* Imagine the father: anxiety, thin care remembered ever after only in pain and absence. This is the way, too, the photographer will also writhe, fallen at the lumberyard where he goes to work in place of his father. Age sixteen, his spine turned to a long spasm of pain, rage, futility. Pain that ends in thinness, darkening his eyes, lengthening his cheekbones. His face bleaches to a papery translucence. Now, whenever his son speaks to him, the father closes his eyes. Turn to the left. Turn to the right. Even then, the shadow of a shadow.

Upshaw, 1878

Always an absence. Something about his mother's reserve, how she speaks only when urged to, keeps him quiet too. It occurs to but frightens the boy to ask if he has a father. Even Mrs. Johnson, the old woman in whose rooms Upshaw stays while his mother works, presses her lips tight when asked. She tells the boy he needs to get that story from his mother. Upshaw has learned to rely on his powers of observation. He knows his mother works at the back of Downey's tailor shop as a seamstress. She has a neat hand and speaks well, the tailor tells him. He says her hands are a credit to her race. Every day, his mother wears a hat that hides her face. She sews tough knots into the silk of ladies' dresses, tats new lace where pieces rip in cuffs or tablecloths. She never stands behind Downey's counter. Each night she tells the boy to fetch a piece of cloth saved from a shirt she's tailored so she can wipe their boots. She stuffs newspaper into the lining of their shoes. She teaches the boy to read from advertisements in the St. Xavier paper, pinching his ear if he mispronounces. Once when he is six, they come across an Indian woman

squatting outside the train station. As he and his mother pass, the woman jerks to her feet and cries out at the sight of them. His mother keeps on walking. Another time, Upshaw wanders out through the tailor shop's alley-side entrance as his mother packs her orders, following the sound of boys' laughter wavering down the boardwalk. When he reaches them, the eldest boy stands up from his game, takes one look at him and shoos him off. Upshaw, enraged, kicks at him. When his mother catches up, packages tucked under an arm, she whirls Upshaw around to face her, then slaps him.

Sign

Walking past the sign at the grocery by the edge of Front Street: No INDIANS OR DOGS. Brown door, the lettering in white paint. Upshaw stops to mouth the words. His mother, gently, pushes him forward.

Work, July 1878

Not a lot of work these days, Downey tell his mother as they leave the shop. It's late August, the air so hot and dry that Upshaw wakes with nosebleeds. He suffered one this morning: the little rag his mother gave him for a stopper is still in his pocket, streaked with rust.

The sun, even late in the day, is blinding. Downey dabs his temples with a handkerchief. *Make sure you use the back entrance,* he warns Upshaw's mother, as he does each day, watching as she gathers her things. His mother folds a shirt up brusquely on the counter. *I just don't want to have to explain,* Downey continues. *You being wife to Crazy Pend d'Orielle.* His mother puts an arm on Upshaw's shoulder. *Say goodbye,* she commands, and Upshaw waves. Downey returns the gesture, his kerchief stuck in his hand, the white cloth shuddering after them in the alley.

North then South Again

Two weeks later, his mother returns early. Says nothing to Upshaw, just collects him at noon from Mrs. Johnson's as if this were her normal routine. Late next morning, she takes him to church, then spends the rest of the day walking him around the little town. The next day and the next are the same.

After a month, the kitchen table, once covered with a white drift of shirts, stays bare. They begin to eat early, so as not to waste coal. They paper their apartment windows. At dawn the last day of September, his mother wakes him to say they are going north. Upshaw rises from bed to find that she has already packed their clothes and some food in her leather case. In silence Upshaw follows her to the station. Two days they travel, north to Billings then south again, sleeping at the station till his mother can beg a ride on a half-breed rancher's wagon. Mountains rise up around them as the wagon jolts over ditch roads, brown hills tufted with evergreen. At a town called Pryor, his mother tells him to dismount. It's dark, the stars like ice pricks in the sky, and as they walk, swaddled in

layers of shawls, Upshaw struggles to stay awake. He can't count the hours they've traveled: snow has seeped through his boots and pant legs, freezing his shins, the blood in his feet, and still his mother keeps walking. How can she know where they are, moving through so much dark? A sudden curve in the forest, and a wall of black rock rises before them. When he blinks he is startled to find what seems to be a ring of smoking cones; beside them, dark shapes of tethered horses, swaying; fires. His mother nudges him, tells him they are home. Upshaw blinks, the small lights swimming in his eyes.

Home

They are at the edge of the Fox's tipi ring. The night wind carries the smells of dry grass and scraped leather and smoking dung. His mother calls out something in Crow and after a moment two women emerge from the darkness and walk toward them. The one who approaches first speaks a steady stream of words that at first sound to Upshaw like coat flaps slapping in the wind. She greets Upshaw, but he can't answer. The woman turns to his mother and speaks harshly, then turns and waves the two of them to follow her.

Where are we going? Upshaw whines as he walks beside his mother. *Who are these people?* His mother glances at him. *That woman is your grandmother*, she says. *This is their winter home. You're staying here until spring.* She pulls her shawl up tight around her throat. Upshaw hunches against his mother as they enter the tipi, falls almost instantly asleep. Through the scrap of night sky wheeling above the smoke hole he sees stars, in his dreams—white clouds shifting through blackness.

Snow

After two weeks of being spoken to through his mother, poked and prodded and laughed at, he is taken by his grandmother past the meat-drying racks into the woods. When they're far enough away that no one can see them, she grabs his hands and begins moving his fingers inside hers. He doesn't understand what she wants, but begins to imitate, saying the word his grandmother signs, moving his fingers. *Tree,* she says in Apsaroke, or Crow, pointing to the trees, then making the gesture for the word as she says it again, until he understands. *Ground,* she begins again, pointing at the frozen ground beneath them, signing, speaking. She points to herself, gesturing that he should also call her mother. She walks around the forest, pointing out the tracks of animals, the frozen river, the stones. Naming them. Soon, he begins to ask questions, pointing to what he wants to say, listening to her word, watching her fingers. It is good to know how to say it two ways, because the Souian seems to evaporate on his tongue. *What's that?* he asks in English, pointing to the white flakes appearing on her shawl. *Snow,* she signs then speaks, fingers flicking, drifting.

SNOW ON THE HIGHWAY my father's car slid across, wet slush over slick road. My father's car hydroplaning into morning.

YOUR HUSBAND BROKE HIS BACK, the doctor tells

my mother at the hospital. I am five. It is winter and a long

sheet of ice has frozen over everything. Just two hours ago

I was standing beside the sink watching my father shave his

beard for work, the dull tap of his razor rhythmic on the

porcelain. I stood, absorbed by the scum and stubble swirling

on the water's surface, ignoring the bustle of my mother in the

bedroom as she folded my father's shirts into a bag. I looked up

at the sound of my father knocking over his cup of coffee, the

mug breaking on the floor.

That's because you're in a hurry, my mother scolded.

It's a long drive to the college, I have to hurry.

If you got work closer, you wouldn't.

Work is work at this point. You want me to stay here, sit around
all day like before?

My mother scraped up the slivers of mug. This was their

argument every week as my father prepared to travel across

the state to the school where he worked as a part-time teacher

of History. *Walla Walla? Do you have to? Isn't there someplace in*

Seattle? I went to help my mother pick up the rest of the pieces.

She sat back on her haunches and smiled at me.

He'll be back soon, she whispered.

At the hospital, the doctors speak very slowly to my mother. *He. May. Be. Paralyzed.* I think they are trying to calm her, but my mother's face has turned purple. She tells me to sit in one of the chairs in the hallway, then starts speaking rapidly to the doctors. The doctors clear their throats and try another explanation, but my mother and I have already gone in to see my father. We have already heard that word Broken, the white mug on the ground, coffee seeping into the cracks of the floor.

SOME PART OF THIS, later, we would find funny.
After the hospital and back braces. After we knew he would
walk. My father's accident was the culmination of what
he called *a long series of disasters with modern technology:*
radios falling off shelves and bruising his head, his allergies
to medication, his bad luck with cars. Most especially cars,
which hurled themselves over curbs and at random cyclists,
cars whose engines caught fire as he sat idling in them. My
father had grown up with his mother and grandmother,
neither of whom liked to drive, so no one had taught him.
He'd had to teach himself at age twenty-three, after driving
his first car with its instructor inside, screaming, into a tree.
One of my earliest memories: watching my father pull out
of our driveway, hearing something groan and seeing the
sudden lick of flame, steam seething from under the hood as
my father, white-faced, leapt from the car.

S*OMETIMES*, my mother liked to say, *it's like the world evolves around your father.*

Grass

We change, Upshaw's grandmother says, when our family leaves. Holds her hands out for him to inspect. Upshaw strokes the knife scars that run along her fingertips, laddering her wrists. The scars are smooth and slightly raised. His mother has no marks like this on her body. Upshaw watches her sit with the others in silence, scraping skins as the young girls skip pebbles on the ice. Upshaw wants to ask about this silence, to ask why he knows almost nothing about her or his mother. He begins to badger his grandmother when they are out in the woods. *Why doesn't my mother have any scars?* he asks.

His grandmother picks up a piece of firewood. *Many years ago,* she says, *after your father, Crazy Pend D'Oreille, defeated the Bull and stole the Lumpwood's songs, he went to the Indian Agent to ask for money. The Fox had sold their land and the Agent should have paid us.* She pauses to hand Upshaw more wood, watches him bundle it in silence. *The Agent told Crazy Pend D'Oreille that if he was hungry, he could eat grass,* she continues. *Crazy Pend d'Oreille was angry, because the Fox*

had lost the land, and now his family had nothing. So he began to pray for the Agent to feel this hunger too, and asked other young men to pray with him. The next day, she says, *the Agent's mouth was stuffed with grass.*

What happened to Crazy Pend d'Oreille? Upshaw asks. He doesn't want to say *my father* yet. His grandmother picks up another piece of wood. *He and the others returned but were hunted down and many were murdered,* she says. *Some of the Fox were angry at this.* She shows him her hands, raised scars left from the knife she used to cut herself. *Some,* she says, *were afraid. Those ones moved away.*

Sounds of arguing near the drying rack. They are back at camp, passing a group of women pointing at an empty pole from which one of the dogs must have stolen meat. Upshaw's mother stands apart, watching them. As they pass, Upshaw's grandmother greets each woman in turn. When she sees his mother, she turns away.

At the Moment When Curtis's Father Dies

The photographer is out in the field taking pictures. Practicing perspective according to the Pictorialist method: focusing in, further, blurring the light so that only the story will be captured, in this case his young wife, Clara, in front of a stand of oak, head bowed as if in prayer over a basket of apples. The story is about innocence. At the moment when his father dies, he is trying to blur out the failed corn rows behind her, a twist of black smoke, the train just pulling around the same corner his younger brother Asahel turns, waving his arms at him, crying.

What You Can Have

Clara comes to him. Standing at the barn door, watching him watch his dead father, the long gray body stretched out on a pallet. Someone had covered him with a shawl. *You should take a picture,* Clara tells him.

He nods, and gets the camera. He looks through it a long moment.

She puts an arm on his shoulder. *Take it,* she says. *You can have him forever.*

What He Read

Dimestore novels about cowboys, Jesse James, Crazy Horse. The Minnesota Massacre: a raid by starving Santee Sioux against the Fort Ridgeley Indian Agency. Around one thousand white settlers are killed, three hundred Sioux sentenced to death. Thirty-nine are hanged. This is the largest public execution in American history. *All through life,* the photographer writes, *I have carried a vivid picture of that great scaffold with thirty-nine Indians hanging at the end of a rope. I paddled my canoe over the lakes of that region of slaughter, hunted and trapped, and drew mental pictures of the horrors that had occurred there.* Fields ripened with flame, white smoke on white sky. Cannon fire.

Under her blanket, the body of his wife groans.

A NOT DISSIMILAR ACCOUNT to the one my father gave me. I'd come home from school, talking about the Sioux, the reservations, what the government did to get the land. *Garbage,* my father said. *What kind of whitewashing is going on in your class?* I shrugged. I was twelve. My father had a study lined with books and diplomas for his many degrees on the wall. He took down a book from his shelf and handed it to me. *They took slaves,* he said. *They scalped. The Sioux and Crow were some of the blood-thirstiest tribes around.* I took the book and looked at it. On the cover was an early American painting of a woman being dragged to her knees, an Indian brave with his fist wrapped into her hair. *They were hardly victims,* my father said. He nodded at me. *You'll understand that if you read.*

MAYBE MY FATHER missed something. From another book in his library, THE SAND CREEK MASSACRE: "There were many white-led revenge massacres that occurred after the incident at Minnesota. The Cheyenne and Arapaho were attacked at Sand Creek, as were the Navajo in Canyon de Chelly. Before the massacre in Sand Creek, Colorado, in 1864, Colonel Chivington reminded his troops of what had occurred in Minnesota. 'Kill and scalp all, big and little,' he commanded. 'Nits make lice.'"

MY FATHER'S PASSION is history. Particularly now
the history of the West, a story of violence percolating under
layers of other violence in which—on the surface at least—
there are no clear protagonists. It was a vision of history
resolutely different from the one I was taught at school, which
my father called sentimental and worked to improve. He
passed me books and articles, quoted details that revealed the
nation as a palimpsest of rivalries and bloodshed, one story
superimposing the next. Whereas school encouraged the idea
of a single narrative working towards its inevitable conclusion,
what fascinated my father was chance—the realization
that the same event could culminate in different theories
of meaning. My father liked to read all the possibilities and
choose for himself. And yet, the coexistence of multiple
narratives didn't preclude a victor. This was his paradox: to
believe in historical certitudes even as he argued continually
against them. Also, this violence equally attracted and repelled
him. One of his favorite stories he liked to tell about himself:
how, having fainted after reading an account of scalping
practices among the Cheyenne, he awoke to find the school's
pretty young librarian bent over him. *Are you okay?* she'd asked.

At which point my father rolled over onto his side, closed his eyes, and vomited on her.

My mother's idea of history is the reverse: there was only ever one story. *What can you do to make yourself happy?* she would ask, time and again, as my father was laid off from the trucking company, the teaching positions. *What can you do?*

My father never knew the answer.

Grass, 1880

It didn't matter that the valley was cropped to nothing but scrub. Clumps of sage that took the place of grass in higher elevations and, lower, only thin brown or yellow sedge under crusts of white, the sedge turning a faint pistachio in spring. Upshaw couldn't imagine eating this grass, rooting for it under the snow as he imagined his grandmother had done, digging around old homesteads they came across, searching for iris bulbs, stumps of carrot, potatoes that had been left. Grass was abundant but useless. To stew it up in thick clots that looked like hair—

In St. Xavier, his mother used to take a handful of green bitters, a pinch of salt, and any bones left over from a meal, and cook this up as long as she could stand it, the windows clouding over with steam until the rented room smelled like sulfur. They'd sit at the table together, hissing this broth through their teeth. Here, in Pryor Valley, Upshaw wakes to an unending wind over deep snow, gets a piece of dried buffalo meat for breakfast, and chews it slowly to last the day. And if there were even less? He thinks of Crazy Pend d'Oreille.

He, too, would sneak into town and steal food, or cut his arm for blood and let his mother drink. But what would his mother do if he were hungry? In camp, he watches her hang back from the other women as they work, scraping and stitching her skins in silence, while the snow outside falls, blanking out the horse tracks and grass, settling on the lodge poles, the wind muffling the sound of his grandmother's laughter.

Spring

One night in March, Upshaw's mother curls beside him, crooning songs she hasn't sung since he was a child. The next day, he finds a pile of plaid and calico shirts on his pallet, a pair of sheepskin moccasins. But she isn't there. The road out of camp where she must have walked glows faint green with the first spring shoots of grass.

It comes to him, years later: *You,* not *we,* she'd said. *You are going to be staying here for the winter.*

In that, at least, his mother hadn't lied to him.

Always an Absence

And then his grandmother. For two seasons she grows thin, bent-backed, her hair gathered in greasy white mats around her face. Then she begins to cough. The week that the women in camp take Upshaw to the Indian Agent's, he wakes one morning to the sound of retching, the sight of his grandmother's blankets shaking around her small frame. He sits up as she peels open the tipi flaps to vomit. When he gets up to find her, her face is crisscrossed with gray, and by her feet in the snow are strings of blood.

Edward Curtis's
"Waiting in the Forest—Cheyenne"

Everything the world gives up
is everything

we won't let ourselves know of it: shadow
of a shadow that echoes out of night
or black or forest or time,

whatever we want to call death now

as if death must be outside
a life, and not more of it:

standing in the little store
clutching a bag of fruit and a child to your side,

stranger hiding his beautiful legs
inside a pair of trousers, hiding his hands, too,
everything below hidden
like an echo or terrible dream: plague

brother, plague sister, Bedouin, Lazarus, leper
with half a face eaten away
and half the fingers—

Why don't we walk out together into the forest?

Why don't we fold ourselves into the dark
and all it promises: easy

as pulling a sheet over the face
before a lover.
As closing your eyes for a moment

and not breathing—

II

Let any one of those who proclaims the Indian race is not a dying one give even a month to a careful study of the subject, and he will forever cease to write in that strain. The serious student of the Indian is constantly face to face with the fact that he is dealing with a life of yesterday—not today or tomorrow.

EDWARD S. CURTIS
from
LECTURES ON INDIAN POPULATION, 1911

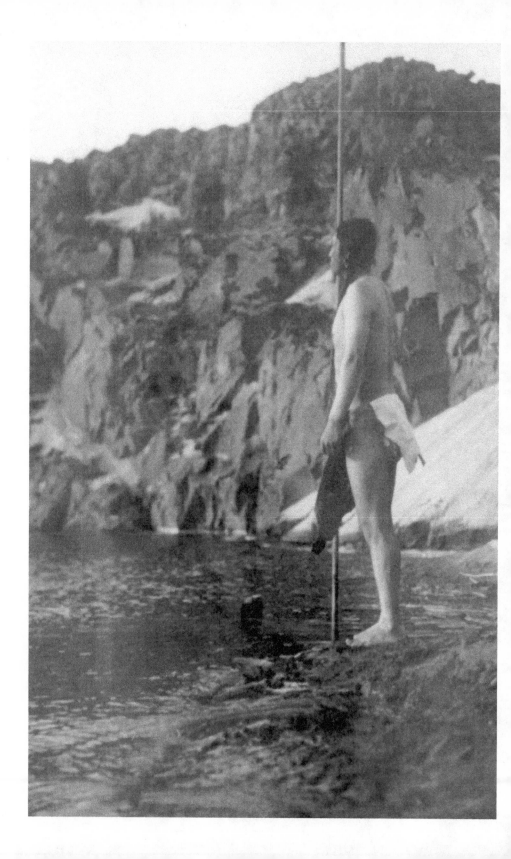

Edward Curtis's "Lewis and Clark's Landing Place at Nihhluidih"

Imagine your point of entry here. Sheer cliffs
of broken rock, razor trees, water
barely gentled at this shore where a man,
pikestaff-lean and shaped

in the chest like the shield
he grips—leather supple as the muscles
on a swimmer's back—prepares to yield.

Or not. This one who marks your place, waits for
and watches your arrival: all witness,

all seeming patience to a discovery
he'll have to struggle to accept; be broken,
relentlessly, into.

It's a defeat
he strangely longs for,
as his posture's stoic solitude suggests.

See his hand raise in tentative
greeting. See yourself

methodically rowing towards the shore.

The sun spreads its rust pool at the far horizon
as he looks you over, eyes squinched tight
against the pressure of its glare.

Imagine your point of entry here. But never fear:
there's only one of him.

MY FATHER WAS RAISED by women. His father had left his wife and child when my father was still young: one of the many Norwegian immigrants who disappeared into Alaska's wild landscapes, camping in tents or on the fishing boats they bought to support themselves. Sleeping in the bars where my grandfather drank himself into stupors. My father's father had died drunk, having fallen into Juneau's bay and drowned. He had died before he'd been forced to sell his little boat, his guns, in order to eat only what could be bought in a grocery store. He'd died just as Juneau became a city, with docks and shipyards, with men strolling downtown in starched suits. After so many months of his being gone, his wife and her mother finally left Alaska, moving with my father to Seattle to find work in a hairdresser's shop. When my father imagines his father, he sees the woods, the ocean, dark sea waters crashing furiously on the beach. When he imagines himself, he sees a small figure standing in his mother's Seattle apartment, itchy in short pants, the clock ticking dully behind him. The closest he comes to wildness there is the stuffed toy dog on wheels that his grandmother gives him to drag down their butter-colored hallway. Each night, he watches

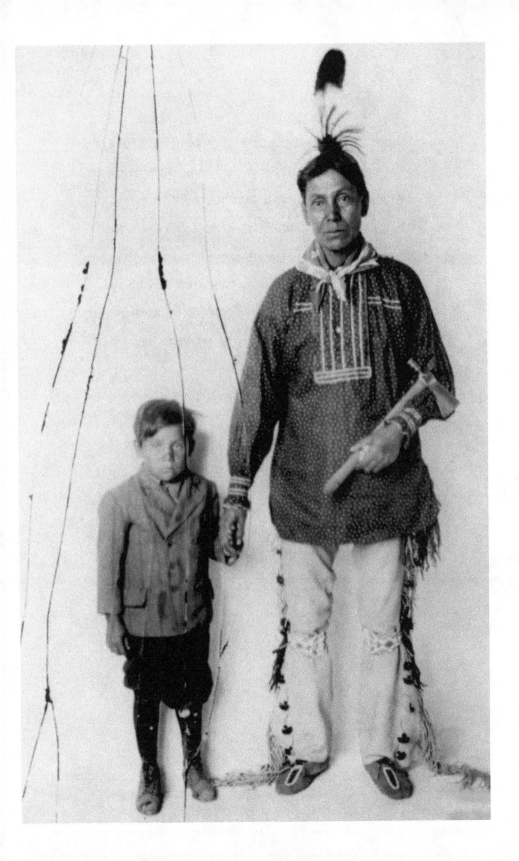

his mother before the dresser mirror. Auburn hair, blue eyes. Face powder ghosting the neck of her dress. He leans against the doorjamb next to his grandmother, and the two of them watch his mother smile at her reflection. In his sleep, he hears the Portland trains coming into King Station, the low groan of their whistles, wheels smashing through the dark. He thinks of his father. The blond head just under the waves, money radiating out around him in a wet, green halo.

Candy

At the Agent's office, Upshaw is asked his name, birth date, his parents' histories. *I don't know,* he replies, worrying the cuff of his shirt. The Agent looks up. *You speak English,* he says. This isn't a question, so Upshaw doesn't answer. In the corner of the office is a rawhide kettle, women's parfleches, an elk-bone bow mounted on the wall. Upshaw's eyes flit over the room. Two weeks after his grandmother died, some of the women had gathered his things, told him he was going on a journey. When he'd asked where, they'd said he was going to join the others of his kind.

The Agent clears his throat. His office is a small cabin with whitewashed walls; the Agent himself is bow-legged and fat, with blue eyes that remind Upshaw of Downey. The Agent turns to where Upshaw looks. *I collect,* he tells the boy, and waves his hand at the objects. *You find anything interesting, I'll pay you for it.* Turns back to his writing. Behind him stares an antelope head mounted on wood. *Did your mother also teach you to read English?* The boy nods. The Agent sits back, satisfied. *Well,* he says. *That will make your time at school easier.* Upshaw looks over the Agent's shoulder into the dead eyes of the antelope.

The school is far away from here in a place that's warm, the Agent says. *Not like these Montana winters. You'll get enough to eat there, too.* He shuffles his paperwork, roots in his desk and comes up with a single hard candy, as if for evidence. He pushes it towards Upshaw. For two weeks, the boy will wait in this office for the Carlisle school officer to come and collect him, sleeping at night on a pallet set up in a corner of the office which the Agent locks up behind him, Upshaw inside. Upshaw will eat the food that the Agent's wife leaves in a basket on the floor, each day finishing with a piece of hard candy handed him by the Agent. Outside the cabin, wind will blow down snow that piles up against the door while Upshaw thinks of camp, the murmuring sounds of his aunts by the night fire, talking as they work. He'll suck the candy and sleep curled up on his side.

When Upshaw speaks of this later to the photographer, he'll say that leaving was his choice. He won't say anything about his mother. Or that whenever snow piles in a thick blanket outside his door, his mouth fills with the taste of stale candy.

Carlisle, Pennsylvania, 1881

Hurry, cries the school photographer, as children are pushed into rows on the kitchen porch. Wave after wave, blinking, arranged by height and age. Apaches from Chiricahua and Pima, a few Apsarokes, Crows: they are the last of the season, dispatched hastily by parents and Indian Agents during the winter to join the school for spring. *Should we sort them by tribe?* asks one teacher, taking gentle hold of one girl by her shoulder. *Or just leave them as is?*

Better to sort them now for the records. Let's start with the Apaches, replies another teacher. A seven-year-old girl trips as she hurries up the stairs, nearly knocking into a pair of brothers. *Look how thin they are,* the newest teacher clucks. *Make room, make room!* shouts the school photographer. The teachers push and nudge the children into rows as the photographer bends behind his camera. He waves one arm wildly for direction. Should they move to the right? The left? Does he want them to smile? *Freeze!* cries the photographer, and the children, not understanding him, do.

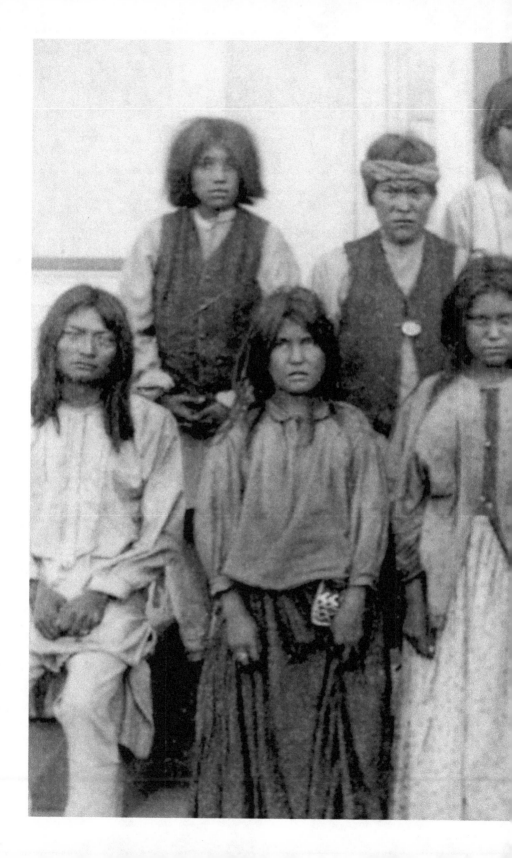

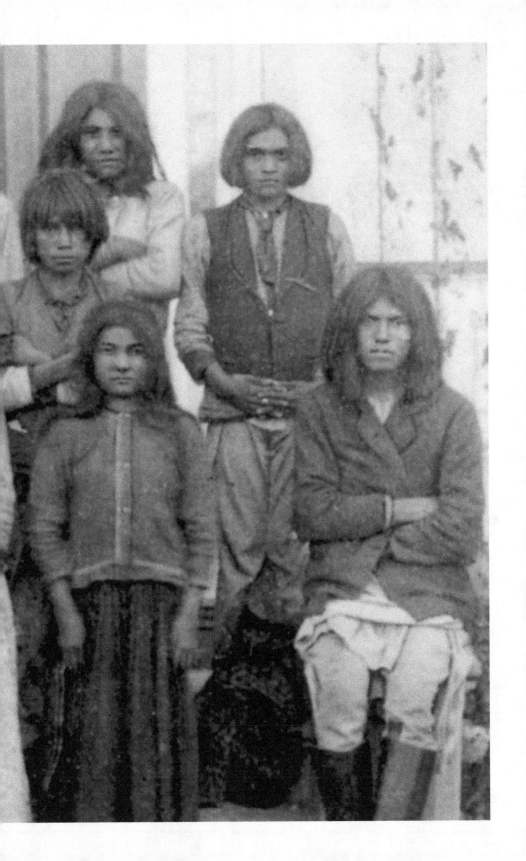

Curtis Studios

The family farm is lost to the bank. In 1887 the photographer moves his wife, Clara, and brother, Asahel, to Port Orchard, Washington Territory, to buy a brickyard, then on to Seattle, to start—finally— his photography studio. ROTHI AND CURTIS, PHOTOGRAPHERS. Then Rothi leaves and Guptil joins him. For a few years, Imogen Cunningham works in his studio. Then it's just him again. Turn to the left, turn to the right. Hold.

DID YOU KNOW that in 2050, whites will no longer be the majority in this country? my father asks, leafing through THE ECONOMIST. It is three hours into my mother's operation. We are waiting in the hospital for news of her, sitting in a long, corridor-like room filled with other families.

I thought that would come sooner, I reply.

So did I, my father murmurs.

I slip my father's Curtis book from my bag. The photos are beautiful, but not as beautiful as the originals, which I'd read were tinted with gold, a process that Curtis had invented himself. I saw a gold-tone portrait once in a shop in Port Townsend that sold "original Curtis prints": originals, because the negatives had been sold by Curtis's Boston publishers, and Curtis was too poor to buy them back. Over the course of his life, Curtis lost everything: houses and wife, businesses and family. The guide he used for his project, Alexander Upshaw, was murdered. My father, noticing that I have his book, looks over.

Amazing that a self-educated man could achieve that, he says. *Nowadays, you have to be born into money. You couldn't do what Curtis did anymore.*

I don't know, I say. *It didn't end very well for him. And don't you think his project is sentimental?*

Of course it's sentimental. But that doesn't mean it doesn't have value.

I don't mean to say that. I'm just surprised you like it.

Why wouldn't I like it? my father asks, suddenly angry. *Why do you think I wouldn't like it?*

One of the families, hearing my father's sharp tone, looks over nervously. After so many hours together, we have all begun spying on each other's distress, perhaps worrying that one family's bad news will soon become another's. My father looks away, goes back to THE ECONOMIST. I turn to the Curtis photographs. The pictures are drenched in sepia. Beautiful, but not quite what I remembered from the shop. In the shop it was astonishing to see that gold really did radiate from the surface of each print, making his subjects' faces appear to hover over the photos. The gold made his figures seem vibrant and dimensional. It made them—if even for a moment—seem alive.

What Makes Him Famous Begins with an Accident

What does he see? One morning at the tide flats, Chief Sealth's aged daughter walks past him, out to dig clams near her shack. Something about her crooked back sequined by light off the water: he pays her a silver dollar for each picture he makes. Here she is, bent shapeless beside the dugout canoe, her face indistinguishable from bandana, her stick and hand a thin blade of light. Backlit, you cannot see the rubber boots or dungarees. You cannot see the bucket or her arthritic hands. Sky takes precedence here, and empty land, and unbroken water. The canoe is more prominent than she is, the sheen of scalloped sand beneath her feet is more textured and alive. Yet imagine her dogged, unstoppable fingers. The quick, sardonic smile as she looks at his work. *Posing for photographs is easier than digging for clams,* she says as she stalks off, one world disappearing into the next, farmland turning to concrete, stone, a field full of houses, no protection with the father there or the father gone. Royalty stripped of meaning, as she has been stripped of royalty. He watches her walk, bucket in hand, ignoring the fishermen taunting from the docks—*Hey Princess, Hey Angeline!*—looking briefly up at the gulls keening above her as they make their way out to sea.

Or: Not Entirely an Accident

So many were already taking photos of the tribes. George Catlin, William Henry Jackson, Will Soule, Adam Clark Vroman, Lisle Updike, William Pennington, Franz Boas, Carlos Gentile and his adopted boy Montezuma. Even Indian Agents took photographs, for instance Major Lee Moorhouse, amateur collector of tribal antiquities, who lived on the Umatilla reservation and from whom Curtis borrowed clothing for some of his portraits. This was a hobby of sorts for photographers, amateur and professional. For Curtis, it became an obsession.

READING AN ESSAY about Curtis's photography, I learn that during the same period when the camera became popular, the government completed its "pacification" of the Western tribes. The owners of the railroad lines, in conjunction with real estate developers, wanted people to see these lands as settled. They hired photographers to take advertising pictures of American Indians to entice travelers out into the countryside.

In this way, the camera helped invent tourism.

In this way as well the camera turned people into events, events into documents.

I recall a story my friend told me. Standing in his Brooklyn apartment watching the Twin Towers fall, my friend had yelled for his wife to bring him the camera.

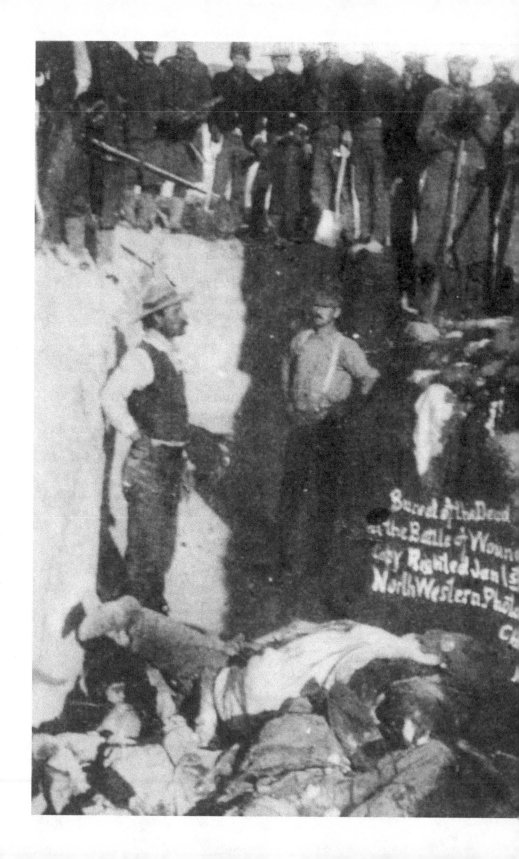

Burial of the Dead
at the Battle of Wound
Copy Righted Jan 1st
North Western Phot
C

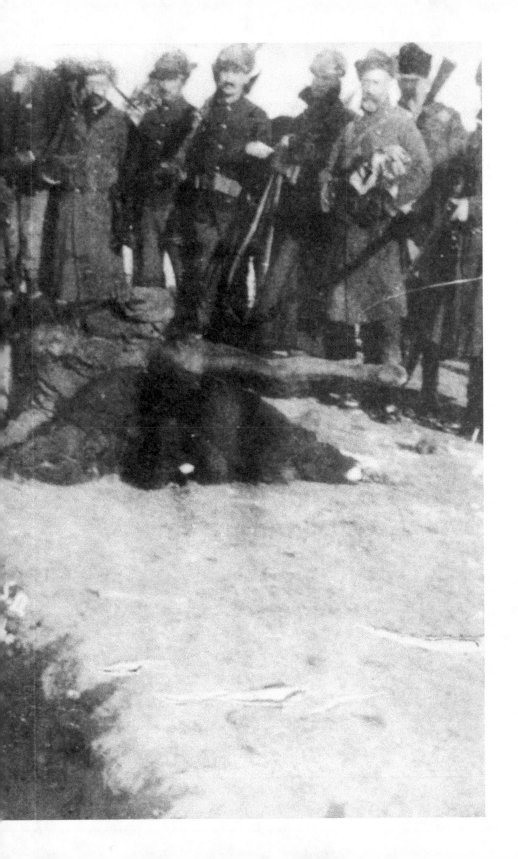

Intimate

We, not *you,* Curtis told reporters. *I worked with the Indians, and not at them.*

Visiting the White House to photograph a group of Indians for Roosevelt's inauguration. Geronimo steps forward in his red traveling blanket, opens the blanket, enfolds Curtis in it.

All his life, he called himself their intimate.

What the Photographer Looks Like

Six feet two, husky-voiced but soft-spoken, blond Van Dyke beard trimmed into a triangle. Up at dawn to work straight through to midnight, writing by the acetylene lamp in his tent. He can hunt, ride, hike for days. Likes—more than anything—being right. Shoots a hitchhiker in the wrist when he tries to take control of his automobile. *Well, heck now, what would you have done?* Smokes. Does not enjoy the company of women or young children. In his storytelling he is not, perhaps, entirely accurate. *You remember that time on the Columbia? Little boat bucking like a Cayuse in a Pendleton roundup, nearly took us all down. She pitched head first into the yawning pit—And here, this photo, that's the whale whose tail nearly broke my hip.* Fathers four children: Florence, Harold, Beth, Billy. Sees them maybe a few months each year throughout his life. Marries once. Clara. Gets initiated as a Hopi snake priest, a Hamatsa; invents the CurtTone, the Counter Current Concentrator; spends the last quarter of his life sifting the rivers for gold. Possessed of an amazing memory. When he gets into an argument over Yukon photo copyrights with Asahel in 1889, the two never stop fighting. Though the brothers live only a mile or two away from each other, they never speak again during the course of their lives.

Naming

"Following the Indian's form of naming man," he tells an interviewer at eighty-three, "I would be termed, The Man Who Never Took Time to Play."

Translator, 1881

The dormitory halls ring like Babel, so many tribes here, so many languages. Fights break out. Children split themselves according to who can understand them, crawl into the beds of cousins, brothers, sisters, but the teachers separate them again, scolding, and march them to their separate dormitories. *Speak English!* The first days, they are chastised if they won't talk. They are refused food, or struck. Then they are isolated. In the cafeteria, the newest recruits sit in silence during prayer, staring into their jelly glasses full of milk. In class, white letters are cursived onto the blackboard: *John has a Ball. Kate has a cat.* Upshaw watches one boy's mouth twist itself with the language, tongue retracting as if he's tasted something bitter. For a long while, Upshaw pretends he can't say anything. One day, a girl needs to leave the classroom to be sick, can't say this to the teacher, and vomits down her uniform. The teacher slaps her. After this, Upshaw does what his grandmother taught him. At night, he begins whispering in Souian, then saying the English, working the other children's fingers into his. Other Apsarokes and the Cheyennes, also knowing,

begin to hand-talk. Even students who have been here years and are fluent in English pick it up. Sign language spreads like fever. The teachers cover the students' hands. *Speak English!* Upshaw's nickname is Two Tongues now—Translator. The teachers rap his hands with rulers. One, trying to be innovative, makes him wear mittens. In the parade yard, the newest recruits march in rows, baffled, staring. *Speak English!* the teachers drone, herding them through their drills. The sound, as it echoes through the grounds, becomes a restless lowing.

Not Rachel

The children are given names in English upon arrival. Alexander, being Alexander, keeps his own. All the others are marched past the Principal, who taps each student jauntily on the shoulder, appointing them a name. Jonathon, Augustus, Katherine, Hope. One Apache girl won't take it. *Not Rachel,* she says when he taps her shoulder. Hair in a long blunt straggle, her uniform skirt's hem already come undone. *Not Rachel,* she insists when she passes the monitors, the teachers, the priest who comes to bless them for chapel. *Not Rachel,* she snaps when the priest gets close, lunging for his hands, her teeth bared. She has small, sharp teeth, very white in her dark face that seems, no matter how long she remains indoors, never to pale. She's dragged out from under desks, out of the janitor's closet, off the windowsills she tries to jump down from. *Dumb as an animal,* the teachers hiss. *No,* she hisses back. She fingers their pockets, looking for keys. They slap her hands, and she slaps back. *No!* she shrieks, tearing at her buttons. It doesn't matter that the teachers say this is for her own good. A dark story the students hear on Sundays: how

if they refuse to be American citizens and be good they will
have fallen. The world will roll on ahead, leaving all the rest
in the dust. Not Rachel yanks her hair out of its braid. She
chews on her collar, tears her olive dress halfway down her
body before the teachers rush to cover her. *You have a choice,*
one of them cries, exasperated, attempting to pin the girl's
flailing arms: *Be a good girl or be punished!* Not Rachel yells
back, *No!* She twists herself in the teacher's grip. She bites
and bites.

Milk

Milk is what the kittens like, the teacher says, pointing to her book, where pictures of cats tumble over a white saucer. *Milk is what they love to drink!* The children look at each other. They drink milk. Every day now, breakfast, lunch, and dinner, though it makes their stomachs ache. The milk accompanies spongy breads and thin stews, pillows of mashed potatoes. All the food is washed of color, like the dingy greys and browns of their uniforms and nightshirts. Even the sky outside is pale and heavy with water, muting the sun, draining the school's red brick. The wind here is not like the blade of ice Upshaw remembers sweeping down the Bighorns, the air so thin and crisp, winter mornings that made him gasp with the first breath he drew outside. There, you had to wrap your face and fingers. Here, the air is like milk. Upshaw fingers the flesh at his waist. So many days inside have turned him thick-bodied as Downey, his face wan and wide as the moon. Not Rachel throws her trays, spills her milk, digs out the little bits of meat she can find in her soup. Only she stays thin, wiry and quiet, black eyes scanning the doors. The rest, particularly the older

students, eat whatever's on their plates. Each evening, the dinner bell rings and Upshaw hears his stomach grumble. The teachers bark at them to line up and the students rush, each one for his place. They trip and stumble. They push, mewling, through the doors.

Dog

Upshaw speaks so well, some of the other Apsarokes have begun to torture him. *Listen to this ghost talk,* their leader snickers. The leader's American name is Robert but his name at home could be translated as Broken Shield. He is the one the teachers punish, the older boy who won't read and so has been held back, grade after grade. Broken Shield has a scar on his neck as sinuous as rope. He is stronger than Upshaw. He backs the smaller boy into a wall and kicks at his feet. *Even his tongue is white!* he shouts in Crow. To prove it, he tells one of the others to grab Upshaw's face, knock his chin up with the flat of a hand so that startled tears run down Upshaw's cheeks. Someone grabs his arms and holds him. Broken Shield begins to pry his mouth open, fingers clamping down on his nostrils so that Upshaw's mouth pops open as he gasps for air. Broken Shield hisses something to the one next to him, and a pair of hands begin rooting in Upshaw's mouth as his tongue is yanked forward. Drool puddles up from his mouth, spills in thick rivulets down his chin. It runs off the fingers holding his tongue, but still the hand maintains its grip. *Look,*

look and see if his tongue is white! He begins to struggle and flail, but his arms have been pinned tightly, and now his whole body is being tilted, lifted, feet kicking just off the ground as more and more children press against him, pushing him up. Upshaw's body wriggles like a trout. He manages to pull his tongue back from the fingers but now another hand digs in, nails clawing at his gums. His tongue feels like it is tearing off from its root. Upshaw makes a retching sound. *He's a dog!* one of the children cries, delighted at the sound, and the children set up a chorus of coyote-like howls. Tears have begun to run into Upshaw's ears. *He's a dog!* the children scream. *A dog! A dog!* And another hand grabs for his mouth.

Science Lesson

In nature, all is unceasing competition. Such are the words he's culled from a book given him by Claire. She is the only teacher Upshaw likes, a half-Cherokee abandoned as an infant at a Catholic orphanage. She teaches civics and science. She wears her red hair in a sleek chignon, lends Upshaw science books in private. She is a student of Hume, fascinated by the principles of cause and effect. She tells the students creation stories in which people and animals make up a chain that links them to each other not by trickery or desire, but by patterns of behavior and biology. This makes sense to them, particularly Upshaw, who knows that the Crow came up through three stages, one in search of water, one in search of land, one in search of the delicate tobacco plant. Claire reminds them that all is change: As their families have turned from hunting to farming to living in towns, so each epoch presents its people with a choice—change, or go extinct. *The instinct of each species is good for itself, never produced for the exclusive benefit of others.* At night, Upshaw thinks of Downey handing his mother packets of shirts, smiling as he ushers her into

the alley. *Competition is fiercest not between distinct genera but between others like ourselves.* How neatly his mother had folded and laid her last shirts for him. Upshaw turns the pages of Claire's book. He reads stories about ants that take other ants for slaves. What would his grandmother say if she could read these stories? In the halls, he waits for Claire, the glimpse of her red hair bobbing through a sea of black. She turns, feeling herself watched, but the sight of him is blocked by two Mohawk boys who have fallen now in front of him, swearing and scratching, wrestling each other on the floor.

1886

Look at the birdie! By the time of graduation, there is no confusion. The children lean against each other, the biggest girl in the group placed in the middle and propped slightly on her side so that the smaller ones crowd her shoulders, nestle into her lap. Each of the students' faces is clean, their heads of hair wetted and brushed. Each body has been clad in the same uniform, the same expression stitched upon each face. *Look at the birdie!* cries the school photographer. The children cluster. They stare, unblinking, in the direction of the photographer.

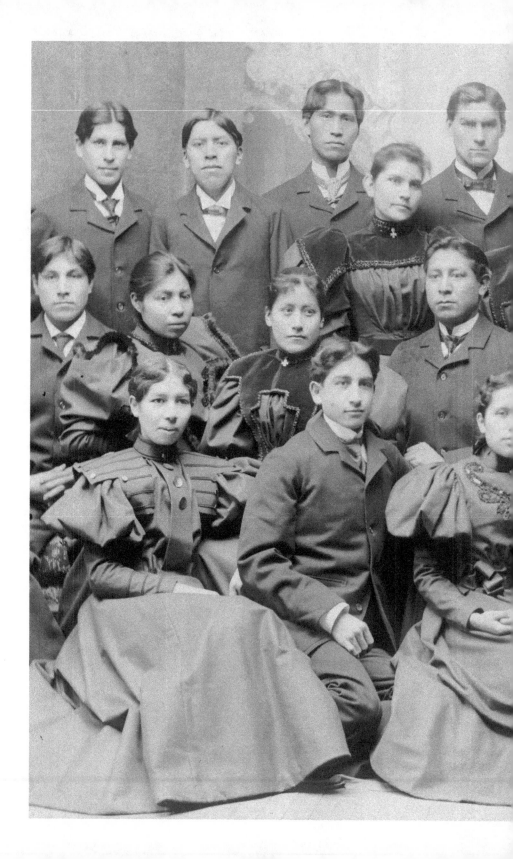

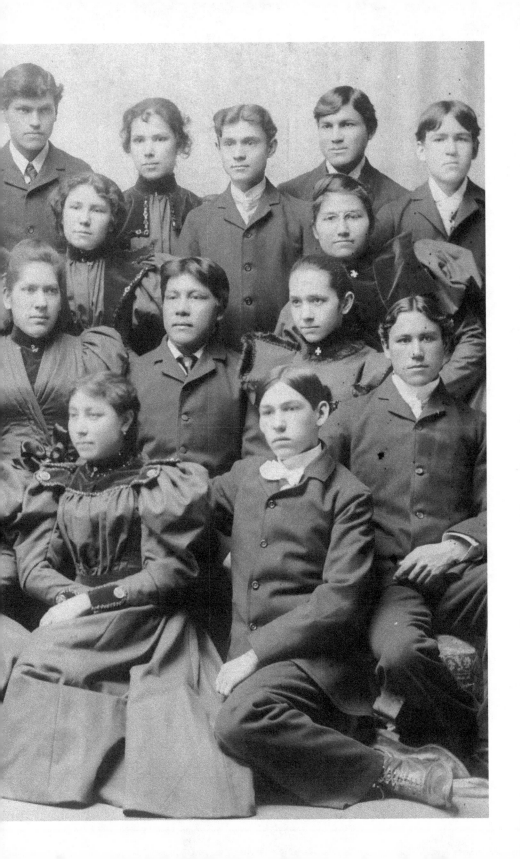

Needle

And still, at night, shimmering beneath his dream's surface:

a drift of linen shirts, his mother's needle piercing the fabric.

Curtis Studios

Nothing motivates the photographer like absence. To stop working is to stop being, to stop working is to become helpless, to feel with no possibility of unfeeling, to live perpetually in what terrifies. Sound of the train rounding the track at night. A cornfield full of weevils. The long, twisted body of his father in the farm's lamplight, the raised scar curved around his ribs slick as a wetted mouth: *I can't stand it here where everything's changed, I've failed and don't have your heart to keep on doing things that come to nothing. Now turn away that lamp. My eyes, it's burning straight into my eyes—*

So

Twenty volumes with accompanying portfolios, thirty-five hundred prints, forty thousand exposures. Each volume 12 inches high, 10 inches wide, 3 and 2/5 inches thick. Bound in Levant Morocco leather, gold-stamped, with seventy-five photogravure plates. Each accompanying portfolio contains another loose thirty-five prints. The size of the photogravure is also the size of the camera: the enormous 14-foot by 17-foot Reversible Black Premo with iris-diaphragm shutter, rising and sliding front, rack and pinion focusing, and double-swing back, which its name implies. His traveling studio is composed of an 8-foot by 8-foot sheepherder tent with a floor sewed in to keep out snakes. No exposure meters, no filters, just a camera, tripod, focusing cloth. Each photo a negative of glass the thinness of six sheets of paper carried on packs strapped to the backs of mules, or stored in wood wagons cautiously trekked into and out of canyons, forests, deserts, ice floes, reservations. A glass shatters, the image disappears. Horses are stolen, cars break down, food is snatched up by skunks or dogs. Flies. Sickness. Breakdowns. Once, a knife at his throat. Forty years of work, only three spent at home. His plan is to sell five hundred sets of THE NORTH AMERICAN INDIAN. Over the course of his life, he only sells two hundred and twenty.

And in Between the Photos, Text

Thousands of languages to learn: In one southern region of California alone, he counts over two hundred languages and dialects spoken in less than that many miles. How can he catalogue everything? He hires assistants. Edmond Schwinke, W. E. Myers, William Phillips. Eventually, tribal members George Hunt and Alexander Upshaw. He learns the sign language of the Plains Indians, the religious practices of the Hopi; he records the songs, the stories, the histories of the Piegans, Kwaikutls, Nez Perces, Apaches, Haidas, Pomos, Assiniboins, Kutenais, Salishes, Iroquois, Inuits, Hidatsas, Cheyennes, Arikaras, Klickitats, Quilcenes, Navajos, Noataks, Mojaves, Papagos, Wishhams, Monos, Zunis, Walapais, Crees, Hupas, Yuroks, Comanches, Apsarokes. Still, it's not enough. It can never be enough.

III

Let it be presumed that at the same time of the discovery
there were a thousand languages in North America.
Probably close to half of those have disappeared, and
in fifty years the present number will undoubtedly be
reduced by more than half. As to tradition, lore, life, and
manners, or in other words, racial characteristics, the
student knows that it is useless to talk with men less
than sixty years old, which proves that as a race they are
almost at the vanishing point.

EDWARD S. CURTIS
from
LECTURES ON INDIAN POPULATION, 1911

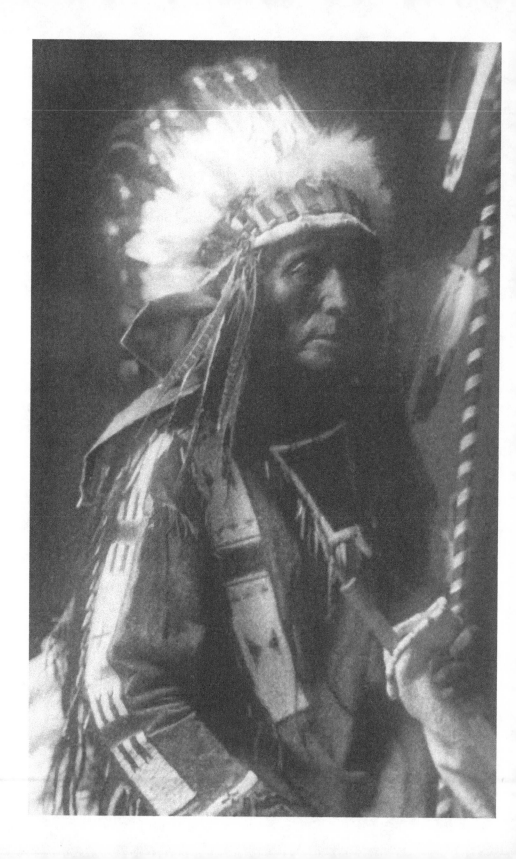

Edward Curtis's "Good Lance: Oglala"

Here's where the light
burns brightest, ghostly furze

that crowns a headdress: a burst
of cold chromatics echoing
on feathers, vest, striped staff,

the very tinting of cheek and lip-
curve, nose like a radiance
of spattered ice. So white

we almost have to squint to take him in, to see
the pattern of his *self* appear, here

where carefully articulated kinks
in the fingers mimic the tunic's hyphenated
stripes, pale bead-blocks that joint
the half-bent arms and thighs: flesh made less

solid by shadow, so all that exists seems
pure bone, the outline of a man

stuffed in his plumage, snowy relic
of a last, good suit now donned for show.

To survive, in this photo, is to remain
all surface, the costume
of one's blanched imprisonment.

His mouth is pursed. His eyes are closed.

For him, to die

is a present act with no possible ending.
Going going going going—

Even alive, he's history.

Imagine the Photographer

He goes into the mountains, the deserts, the Arctic wastes. He packs up leather bags of books and camping gear and old clothes, borrows the last $5,000 on his house, leaving his wife at the studio, pale lips screwed into a line, the children sitting in the kitchen like a series of questions, *When will you* and *Why can't I* and *How.* He takes the earliest train out of Seattle, past docks and shipyards, down through Portland and San Francisco and then Los Angeles, each city another layer of clothing stripped away, until he's on the back of a mule riding past mesas and scrub line, all to record what he cannot now believe still exists. Or exists in fragments, figments. Even now, the future is erasing the past, assimilating the world so rapidly there will be no difference in a later generation. Outside a church, a family of Apaches clad in calico and denim, the men's long hair tucked under cowboy hats. A child calls out in English. The photographer rides past farms sustaining little but space, the few sheep looking shriveled. To photograph this place is to insist on presence, ritual, continuation. To photograph it so beautifully is to insist on a formalism nothing else in life can match or answer.

1887

Unless we break away from our tribal relations and go out into the world as men and women, we will remain Indians and perish as Indians. So Upshaw writes for his senior article, published in the school's gazette. A copy has been sent to Bloomsbury State Normal School as part of his application, along with Claire's glowing reviews. Upshaw is Willing. He is A Future Leader of his Race. He has already begun to prepare for this, traveling to schools with Carlisle's stereopticon and a round of archival photos, hoping to assure his future fellow citizens that men like him are nothing to be feared. He was surprised at the school's depth of records made available to him, so many images boxed and numbered, filed away. *We sell them,* the secretary confided. *Some of our subscribers like to collect.* On free afternoons, Upshaw searches for pictures of himself and his schoolmates. Most are there, but some remain absent. Not Rachel, for instance, is nowhere to be found, perhaps because an image of her would remind the school of its embarrassment. Upshaw remembers the morning he'd staggered awake at dawn to use the water closet and heard

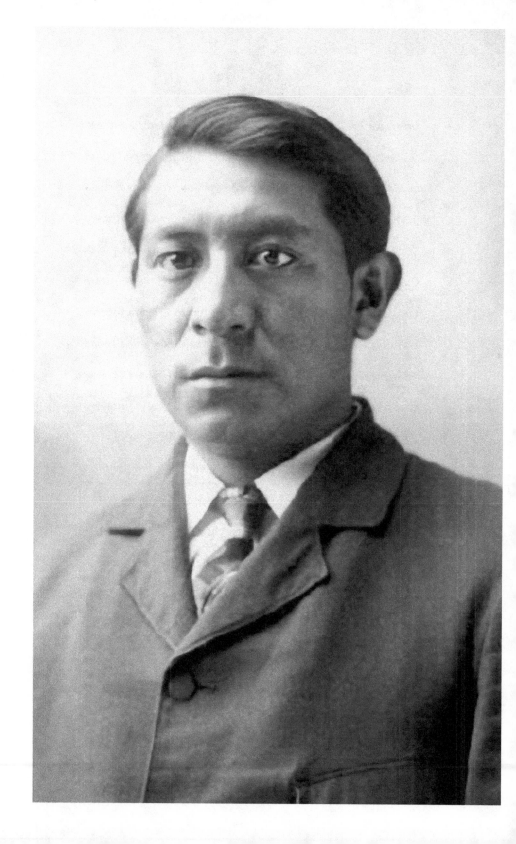

her thin cry somewhere on the grounds. When he went to the window to investigate, he saw Not Rachel running in the courtyard. Upshaw realized by the way she was dancing, clad only in a nightgown, that she'd finally escaped. Upshaw watched as Not Rachel hopped, barefoot and ecstatic, over the school marching grounds towards the gate. His breath steamed at the window.

Now, on the train to the town where he will give his lecture, he thinks about the absence of Not Rachel in the photographs, how clearly he could once recall her face, how indelible to him her features had seemed. Now, he can barely remember her. Upshaw clutches his stereopticon case and hunches in his seat. It was as if she'd been disposed of, the very possibility of her expunged from the record. When he'd passed Claire just this morning in the hall, he'd tried to ask about Not Rachel, blushed, then blurted instead, *I hope you will remember me when I am gone.*

Fields and fields of brown and yellow shoot past the window. His face is shadowed in the glass. Did Not Rachel die out

there, shivering in her nightgown, alone? A photo of Claire,

her red hair, the neatness of her pinafore, is stuffed inside his

pocket. He presses his face closer to the window. A stand of

trees whips past the tracks. Something small is moving inside

of it, he notes, but it's gone before he can focus on it, too

quick for his eye to catch.

Quapaw, Cherokee, Chickasaw, Shawnee, Powhatan, Seminole, Miccosuke, Catawba, Creek, Arkansas, Choctaw, Caddo, Apalachee, Moneton, Manahoac, Saponi, Kashnanpo, Occaneecki, Florida, Tuscaloosa: There are no photos of the Southeast peoples in The North American Indian. Geographic constraint meant that they lived closely with both blacks and whites; thus these tribes, in their appearances and relationships, were increasingly mixed. Perhaps they were, in their presentation, too much like the Carlisle school Indians (including Upshaw) for Curtis's taste. Others would photograph in the Southeast: Here's Mark Harrington's Last family of potters and pipemakers, Pamunkey, Virginia, 1908. So many children of darker or lighter skin surrounding the same mother. The figure I focus on is the girl in back, around twelve, her long hair curling and loose, face similar to her mother's but the color somehow out of step with her features which are rounded, widened, shaped like a completely different person's, which might make her appear to be a poseur in the family: a fake.

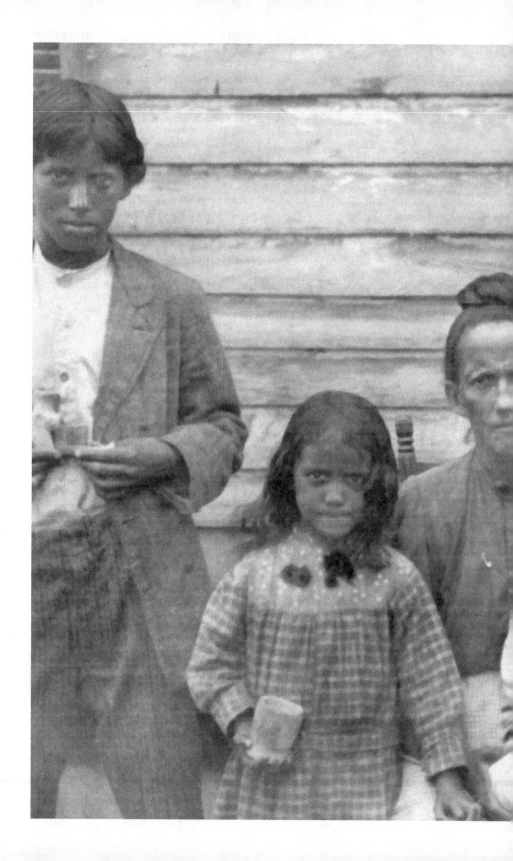

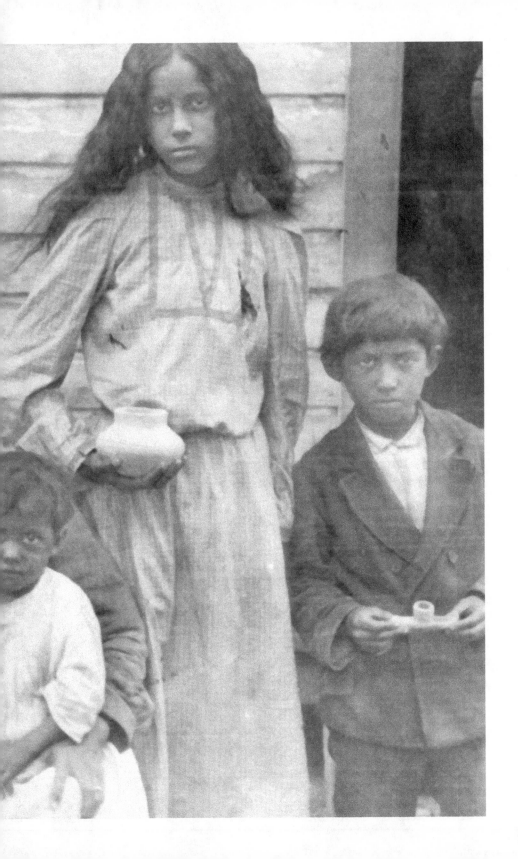

OR THIS MACLEAN POSTCARD titled "Indian woman and child": the woman in her sleeveless gingham, light brown hair pulled back, pale and fleshy arms raising a pale and fleshy child bundled into a corset of leather. Without the physical fact of the cradle board, perhaps only something hovering about the eyes, something about the roundness to her face, suggests what the title itself must insist on.

Do WE STARE HARDER, trying to penetrate beneath the surface to what must be the realer face, lurking? The body beneath its clothing, its hairstyles, its changeable masquerade. Beneath or outside of all the other bodies that created it, too, mixing what we might imagine is "original" to its thinnest trace. To find this face would be like trying to find a coin under shallow but fast-moving water, a quick glimmer of what, if we thought it had meaning, could be grasped—pulled out—shaken dry, placed under the light. You see: That's what we were searching for. Not the thing above, but the thing down there.

At my first job, the manager asks for my racial information to fill out the forms. He looks at me. Checks the little box marked "Other."

The thing that can be seen, but will not be spoken out loud.

You know, my father tells me, *in some lights you could pass for Indian.*

IV

Whether the American aborigines are a vanishing race or not, the vital question is one of culture rather than numbers. The person with one sixty-fourth Indian blood, who knows no word or tradition of the Indian, can scarcely be counted as forming a part of the Indian race.

EDWARD S. CURTIS
from
LECTURES ON INDIAN POPULATION, 1911

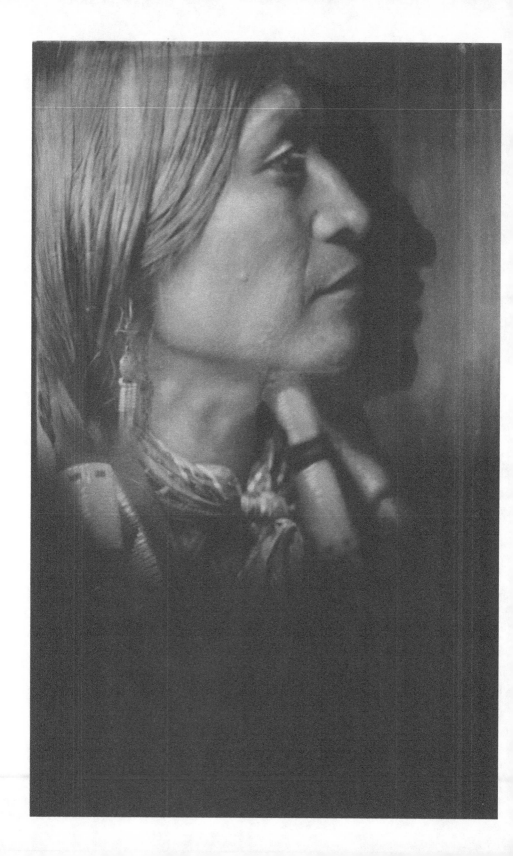

The Lecturer Discusses
Edward Curtis's "Vash Gon"

The heaviest exposures turn black to grey, a clay-like
texture that muddies his locks. Look:

on film, white skin is already reasonably light red.

Optimum reproduction, thus,
is never "exact": to duplicate a subject's appearance
you must experiment with the chemistry
of photographic stock.

 Remember aperture size, length
of development, even the plush depth of the light
filtering onto your set to help you get the face you want
just right.

 But careful:

in mixed groups, not everyone is equally shot.
Recall those stills in which
Poitier posed by Katherine Hepburn
and her face came out looking like beefsteak?

Try warmer lights, bastard
amber gels and tungsten on dimmers to avoid
disappearance: dark kills

most detail, creating the look (as you see in this photo)
of all head, doubled with shadow.

Though the pose he's chosen
seems familiar, doesn't it? Washington's profile

slicing the Delaware, so straight that gaze takes us
back to the wet and brilliant ice;

those cold, white stars;
the rocking of the frozen boat—

And yet here the lashes appear
powdery and false.

It's the technology he chose, you see,
its deceptive gestures towards mimicry
that in the end makes all our faces
hemorrhage light.
Careful composition is the key to human beauty

so balance your subjects, examine your make up.
Shoot daily. Remember:
on film, only the imagination

never disappoints.

Genoa Indian School, Nebraska, 1898

A woman approaches Upshaw at the school where he teaches, clutching a cut-out article. *Is this you?* she asks shyly, handing him the paper. There he is, front and center at the Trans-Mississippi International Expo, clad in borrowed headdress and necklace, standing beside the delegate Crows and a gleaming row of new train engines. "Technology for a New Century!" reads the sign beside them. Upshaw flinches. The outfit is unlike what he wears to school, his uniform of sober necktie and jacket, starched collar high and formal. It is also unlike what he would choose for his own portrait, the one taken at Rinehart's studio: himself, in cowboy shirt and pants, thistles stitched in yellow up the breast and thighs. For school, Upshaw keeps his hair cut short. He polishes his boots. In the woman's photo there is a smudge across his face from where the paper has been folded. This makes the headdress appear to sprout from his scalp, as if he were some exotic bird. He looks at the picture and feels embarrassment slowly work through him. *Those aren't my clothes,* he tells the woman. *The photographers told me to wear that for the portrait.* She smiles.

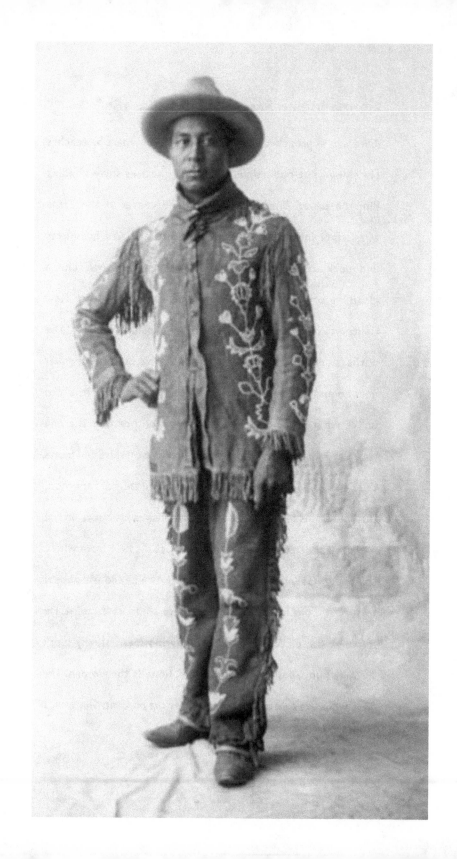

I wouldn't think they were, she replies. Relieved, Upshaw says he was there working as a translator. A Crow named Pretty Shield had contacted him after his article appeared in the Carlisle paper: "What the Indians Owe to the U.S. Government." Upshaw stops himself. He has begun to brag. None of the delegation's ideas were his own: he was only a tongue, a voice echoing other voices. The woman smiles. She has blue eyes, a straight and even nose. She is one of the white women who works with the children at Genoa, marching them on the parade grounds for exercise. *I'm Emma,* she tells him. *You must be proud, being a translator.* The skin of her pale brow crinkles when she smiles. Her hair, he notes, is red. And her teeth are very white.

How did you two meet? someone asks. My father and I, still in the long waiting room at the hospital, look up from our books. Across from us, an older woman is gently quizzing a distraught younger couple about their courtship. The younger couple, from what we can tell, have a child undergoing an operation for a tumor. The older woman, looking tired but smiling persistently, is doing her best to distract them. The young mother says something vague about a bus ride to Snoqualmie, gulps, while her husband sits blankly by her side.

My father goes back to his book. Stories of courtship do not interest him, possibly because his own was so nerve-wracking. When my father and mother got engaged, my mother flew home alone to Seattle from Paris to tell her mother and ask her permission. That year, my mother was teaching at an American school. My father had been stationed with the Air Force in Germany. My parents had known each other since college in Seattle, but had begun dating in Europe when my father discovered they were both on the same continent and, more importantly, away from my mother's parents. My father had plans to go back to school after Vietnam, to finish

his Ph.D. and become a college professor. My mother would become a schoolteacher. But when my mother came home to Seattle to tell my grandmother, Po Po, all of this, Po Po wouldn't even look up from her newspaper. The two were sitting in the living room, Po Po in her worn green chair, my mother on the couch. *Mom,* my mother said. *I'm thinking about marrying him.* She didn't clarify the "him"; Po Po had already several times hung up the phone on my father. Po Po sat reading her paper. My mother waited. *Mom,* she prodded. Po Po turned another page. Without looking at my mother, she said, *Your father would be ashamed.*

BUT MY GRANDFATHER, Gung Gung, was not ashamed. When my father called his mother, Irene, to tell her about the foiled engagement, she decided to approach Gung Gung by herself. From my mother on the phone, she learned Po Po's work schedule, got the address, and went to their house when she thought Gung Gung would be alone. This was the first time my grandfather had heard of the engagement. He invited Irene into the house to discuss it, to see how they might change his wife's mind, which was when Po Po, sick with a sudden headache, pulled into the drive. She found them sitting together on her plastic-covered sofa, a dish of salted plums on her table, cups of coffee fresh in their hands. My grandmother Irene remembers how stiffly Po Po came in and greeted them. How politely she offered her a tray of cookies and then, eyes to the ground, walked to her bedroom alone.

My MOTHER FLEW BACK TO PARIS and married
my father. Po Po had not consented, but Gung Gung had,
and that was enough. She knew once they married, Po Po
would come around. Sure enough, six months after the
wedding, a box of gifts arrived in France by steam ship.
White dinner plates and tablecloths, a set of crystal glasses
my parents would never drink from. All store bought,
nothing from home. Nothing Po Po had ever promised my
mother as her inheritance.

WHEN MY MOTHER WAKES in the hospital after her operation, my father and I are both hopeless with nerves. I nearly drop a pile of magazines onto my mother's stitched stomach, my father almost trips on her IV. We are a family that eats when scared; my father and I have been waiting so long for her to wake up, there are almost no snacks left now in the bag she packed for herself. My father notes this with horror and plans to rectify it with an immediate trip to the café.

Don't bother, my mother tells him. *I'm not hungry.*

How do you feel?

My mother looks at him. *Like someone just took out my uterus,* she says.

And besides that? my father asks brightly.

My mother ignores us and turns on the TV. The only thing on that is interesting is a special on miniature hippos, so we listen to that while my mother dozes. My father and I watch her. I notice, for the first time, how strangely changeable her face becomes in sleep.

Someone in the hall crashes a cart into some chairs. My mother winces awake. *Now I know why Po Po complained*

so much about the hospital, she murmurs, and my father and I freeze: We remember, at the same time, that Po Po had breast cancer, twice. How had we not remembered this before?

My father pales. My mother falls back asleep. On the TV, two miniature hippos have begun to chase each other. They move so slowly, even enraged, the camera barely has to swivel to capture them. Now one struggles up the bank of a river, lumbers over the hill. Half a minute later, the other does the same. My father and I can't help ourselves. Terrified, we laugh as we watch the hippos waddle in circles, tears squeezing slowly from our eyes.

M Y MOTHER ONCE CONFESSED that Po Po's objection to the marriage in part had to do with children: *What would happen to them,* she asked my mother, *what would they be?* It occurs to me that I can trace my mother's cancer through the bloodline: breast cancer, uterine cancer, pancreatic cancer. An aunt who died last year of brain cancer. All within my mother's family. And on my father's side, a different raft of disease, some heritable: colon cancer, alcoholism, a rare form of cancer of the neck. *What will happen to me?* I wonder. Perhaps, though Po Po was wrong in her dislike of my parents' mixed marriage, her worry for them, and for me, was a prophecy, if accidentally.

WHICH MAKES ME SUDDENLY understand something new about the Curtis photos: Despite the high rate of miscegenation among the different tribes, he didn't photograph mixed families. Perhaps to preserve a particular impression that would attract white interest in his project, highlighting Indians' essential difference and their isolation from white Americans, keeping the images at once exotic and reassuring. Curtis's refusal to photograph full-blooded American Indians in contemporary garb also suggests that, for him, being mixed-race was not just a matter of blood but self-presentation. The sight of a family being mixed in any way, by blood or by the changeable trappings of culture, would disrupt his audience's definition of—or their demands upon—Indianness and whiteness.

Indians

Not vanishing, but changing. Not static, but even now weaving their way through the bloodstream of a thousand other faces. Altering both the viewed and the viewer.

Geronimo steps up, opens his blanket, enfolds him within it.

FOR PO PO, my cousins' and my Chineseness was in direct proportion to our proximity to her: As long as she could speak to us, touch us, instruct, we were her children's children. Alone together, she scolded me in Cantonese, while, with a steady stream of English, she baked custards and knit sweaters, taught me dishes I should cook. When my father arrived, she switched solely to English. Her friends would come and touch my hair, tell her how tall I would grow. Po Po would wave away the compliments. If pressed, she'd say I looked like her daughter.

Meanwhile, my father couldn't seem to name me as either part Chinese or part himself. Instead, he'd tell me I looked like a Kurd, a Uighur, a Russian, a Slav. *What a relief,* he'd say, *you didn't inherit my features.* Sitting at the dinner table drinking his beer. Pushing the glass, suddenly, away. *I'm finished here.*

WHAT CURTIS DID was understand that the eye could see before it saw. He knew that each photograph came accompanied by a text, even if the words only appeared in the mind. Isolated from writing, his photos are art. Enclosed within explanation, they become a pseudo-documentary. When Curtis hired Upshaw away from Genoa on the strength of his reputation as a translator, he told him that he'd be in charge of finding "native scenery." He'd be good at this job, Curtis insisted, *because you fit here.* They stand together now on one of the Crow buttes looking down, wind whipping their shirts tight against their chests. Upshaw hasn't been to Montana since he was a child. Somewhere below them, the faint white and dun bodies of antelope. Curtis smiles, claps a hand on Upshaw's shoulder. *You're home,* he tells him. I imagine all the muscles in Upshaw's back tightening.

Spring 1906

From the back of the Seattle studio, Upshaw watches the photographer's family unload their crates. It's been five months since he was hired and Upshaw can see that the man's beard has grown and there are puffy, almost purple circles and new lines under his eyes. The photographer is determined. He works long hours in the field in his darkroom tent, more hours writing. He doesn't rest, lacks a sense of humor, never asks after Upshaw's wife. Emma thinks the man is cold, but Upshaw grudgingly admires him. *His attitude is necessary for the work,* he tells Emma. *And who else is willing to pay for a translator?* But Emma, left alone for months at a stretch, disparages the work. *They are only photographs,* she says. *He is just a tyrant.* Still, the photos help pay for their growing family. Upshaw can't help thinking of his infant daughter now as he watches the photographer's family flit anxiously about. Beth, the photographer's youngest, hangs back, shy, fascinated. She can't stop looking at this half-stranger her father has become, staggering through the door under the weight of crates shipped all the way from Montana and Wyoming,

breathing in the scent of these magic glass sheets, as he peels the silk away from the first exposures, albumen and sulfur and packing hay, the smell sweet and bitter. The photographer's wife, Clara, asks in a low voice if there are more. The photographer doesn't answer. His boy, Harold, runs up almost underneath the box crate Upshaw carries, rattling the piles of glass, so that his father is forced to stop and scold him, pick him up solely so he can move him away from *what you're going to break, dammit—Clara, can you just get them back?* Clara, angrily, picks up a plate, thrusts it to the light. Beth squeals as the weak sun bursts through the patterns on the negative: it is the river that winds down from Pryor Mountain, the first landscape that Upshaw selected, and he imagines his own daughter, Sara, how she would look standing in front of the image. Beth claps her hands and asks to hold it, but the photographer shakes his head. *Not to touch,* he warns. *Your mother is holding that man's home in her hands.* He points his finger at Upshaw and both daughter and wife turn. Upshaw nods and they nod back, the wife's mouth tightening slightly as she looks at him.

NOW YOU'LL GET CANCER, my father says on the bus ride home from the hospital. *That happened to your mother and her mother.* He stares gloomily out the window at the passing traffic.

I am used to my father's pessimism. Ever since I was a child, he's liked to repeat two warnings: (1) *The man you marry will spend all your money then divorce you.* (2) *Life is living out each one of your worst nightmares, then dying.* My mother calls this "his Norwegian tendency."

Mom's going to be fine, I say, changing the subject.

My father doesn't answer. He doesn't have to tell me: *You don't know this.* No one knows this. The look that settles on his face now is the same one I've seen at different times in his life. Watching him struggle at home on the stairs, back from the hospital in his brace. The way he'd looked after I said I was getting divorced. That morning in the living room after he discovered he'd been let go at work.

It makes sense he would return to the disease's genetic possibilities. My father has been obsessed with genetics since he read THE BELL CURVE and announced to my mother and me at dinner that night that the Chinese were, in intelligence, second only to the Ashkenazi Jews.

As for me, he continued, *Scandinavians are evidently on the middle to low end of the spectrum.* He laughed, picking up his spoon. *Too bad for you,* he told me. *You could have been smarter. Like her.* He gestured with his spoon to my mother in her slim black suit, just home from work, then to himself, clad in his blue bathrobe. My mother got up to rinse her dishes. My father went back to digging in his stew.

AS A CHILD, I was often confused as to who was Chinese and who was white. I thought David Carradine was Chinese. I thought Yul Brenner was Chinese. I thought Tom Brokaw, who looks like my mother's youngest brother, Kingsley, was Chinese. Everyone was potentially Chinese, just as everyone was also potentially white. Perhaps it was because the meaning of my own race changed according to my parents' wishes, depending on which characteristics they wanted to emphasize. As if I was a photo beneath which the caption was being, continually, re-written. At age twelve, when I asked my mother if the Eskimo face on the back fin of the Alaska Airlines planes was a portrait of Johnny Cash, my mother looked at me and said, *I don't think we're raising you right.*

Wʜᴇɴ ɪ ᴅᴇᴍᴀɴᴅ to know if I am in fact Chinese,

my mother replies: *A part of you.*

What part?

She doesn't answer.

Snake Dance, 1907

The photographer wants to take part in the snake dance. He tells Upshaw this, steering the Rambler over a sudden outcropping of rock. He laughs, imagining the dance, imagines passing for Hopi. Every year, more and more cameras—the kivas are ringed with Kodaks, causing the Hopi to bar outsiders from the ceremony. Upshaw shifts in his seat. Perhaps the photos have become too indefinite for the photographer, he thinks. The photographer has begun to collect: songs and stories, pelts, baskets. The photographs, on their own, are no longer enough. In their beauty, the photos have begun to blur. One after another, they pile up, face after face until the photographer begins to imagine that to lose a single image would be to lose the project entirely. Whenever they travel over mountain ridges rutted with stone, Upshaw is sure the thin car doors will fling themselves open, the crates tumble down, glass smashing onto the rock below. He sweats when packing: Each crate is months of work, filled with faces that will never again appear.

They'll see your hair, Upshaw warns, but the photographer shrugs.

I'll cover it with mud, he says.

The Rambler bounces, and one of the crates rattles ominously. Upshaw's arm snaps out to protect it, and the photographer's eyes flit to the back seat. Satisfied that the crate is fine, he turns his eyes to the road again.

Americans want to get close, he reminds his guide. *I might be as close as they come to the Indians.*

From beneath a sage bush, a jackrabbit suddenly darts onto the road. It zigzags in front of the Rambler, dodges and weaves as the photographer tries to drive the shuddering car around it. Upshaw feels the car tilt, the photographer pounding out a little beat of frustration on the steering wheel as the crates bounce, both men grimacing at the sound. Upshaw throws himself toward the back seat. As he moves, Upshaw sees the rabbit dash off again and feels the car, miraculously, right itself. Upshaw peels his arms from the crates. The photographer, slowly, breathes out.

V

Rather than being designed for mere embellishment,
the photographs are each an illustration of an
Indian character or of some vital phase of his
existence. Yet the fact that the Indian and his
surroundings lend themselves to artistic treatment
has not been lost sight of, for in this country one
may treat limitless subjects of an aesthetic character
without in any way doing injustice to scientific
accuracy or neglecting the homlier [sic] phases of
aboriginal life.

EDWARD S. CURTIS
from Volume One of
THE NORTH AMERICAN INDIAN

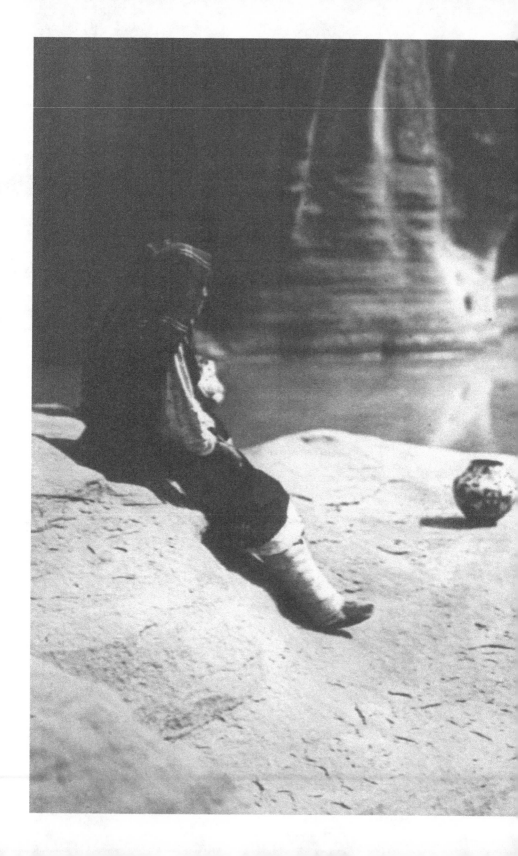

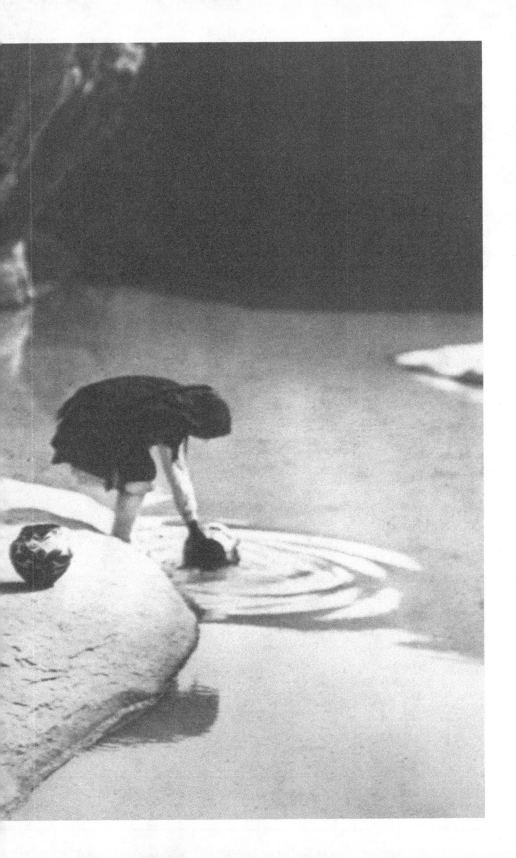

Edward Curtis's "At The Old Well of Acoma"

Repetition depends on expectation. So does pleasure.
The same dark back, the same cold water.
What can we do but follow?
The hunched back of the girl
holding her pot to the river, black
and white on black and white,
another girl sitting, watching, watched—
How could we not have seen this,
how could we not have wanted it,
the thought of these girls like a strand
of hair lingering across the mouth, a caul
of heat over the picture, indelible,
something no hand can tear away?
We can already feel their beauty
entering us, each slim and solitary figure,
shapes the mind can contain and calculate.
And if there is a math, a form,
isn't there also a story?
What changes if we know
that one is later sent to school and runs away?
That one takes a train, becomes a housekeeper,
comes home sick with tuberculosis?
That on the river that day light cut
and bled into the water
and the older girl sang a song
the younger would never hear again
but keep on imagining,
snatches of it tucked away
as if the girl had never stopped singing?
Go back. Don't even look at their faces.
There will be a husband for one or both, perhaps.
Children. Sickness. A death

for everyone. They will pack up their hair bands
and laces. They will go home to wash
a skirt, rinse stones
out of the beans, scrubbing their hands,
their fingers, rinsing out a wound.
Some of the water will spill
onto the ground as they walk.
One beauty ends and another begins.
We don't imagine an after.
Only the pattern of life: an increase,
then a pruning back.
Long field of dust, scarf
of dark plaid in a trunk folded over a pair of leggings.
Women gathering by the river,
light swelling in their faces,
everything touched, everything sticky
and imprinted. Watch: They will put on new clothing.
No one will braid her hair this way anymore.

The same dark back, the same dark water.
One girl, and then another.
Somewhere, the other story resides
as if unwatched:
when one of the girls begins to cough,
the other turns away.
Her mouth shaped like the other one's.
Her hair longer than the other one's.
Between them, light fingers the water.
And the white pot on its cool stone—
Go back. It is still peaceful here. Here,
only the well grows old.

Little Plume and Yellow Kidney: Piegan

Curtis sits the Piegan men at the end of their lodge. He likes the way they look: corrugated foreheads, thin braids shining against buckskin. They could be brothers, not father and son—their similarity makes them uncanny to see. Before the camera, they blend together, taking on the stiff posture of Victorian girls, hands in their laps and faces turned demurely to the side. He shakes his head. *Look,* he tells the men, *like you know what it is to be among the living.* The men glance at each other. Grinning, the photographer orders Little Plume to sit with one leg bent, with a hand firmly gripping his knee. Yellow Kidney reclines, resting on the strength of one arm, holding an eagle-feather fan in his lap. *We have to make you look commanding,* Curtis says. *Stay like that.* Father and son look at the camera. They do not smile. The photographer takes the picture. *That's it,* he tells the two. *Your family photograph.* Not until later does Curtis see the clock propped between them, its brass body squat on a little mat woven with rushes next to the tobacco-cutting board. He needs all day, but the photographer manages to scratch the clock's image from the glass. In its place, he retouches in a fragile little basket.

In the Mandan Camp

Upshaw, on his knees, puts his hands on the blanket wrapped around the Mandan's Sacred Turtles, a pair of leather drums shaped like turtles. The Mandan shaman, watching him, sinks back on his haunches. *Tell us,* Upshaw presses, translating for the photographer. The shaman turns his face. He has begun to cry. He is an old man, nearing seventy, and Upshaw can see that the slack skin of his jowls and belly hangs in desiccated pockets, the skin of his underarms tissue-thin. The man covers his eyes. Upshaw has been negotiating for months with him, for the photographer, and again and again the shaman has put him off, refusing to talk about the buffalo-hide Turtles. The Mandan boy they have hired as second translator for the week looks over at the photographer. Upshaw tells the boy to unwrap the blanket and put his hands on the sacred objects. *You've been telling us lies for weeks,* he scolds the shaman. *The gods are angry with you. If you lie now, they will know. They will come and punish you!* The shaman shakes. *They're looking at me!* the shaman wails, as the boy's hands shake over the Turtles, which makes Upshaw swallow, though he translates

this to the photographer who sits in the back corner of the lodge. The photographer begins to write. Upshaw watches the boy place his trembling hands over the tight, ancient buffalo leather, and he has to fight the urge to smack them away. Sweat has begun to bead up on the boy's face. The shaman begins to talk. Upshaw translates. The boy has a slick sheen in his eyes. When the shaman is finished speaking, Upshaw nods to the boy who gets up, goes outside, and hides for the rest of the day. Quietly, Upshaw rewraps the objects. From the corner, he hears the quick, hard sounds of the photographer's writing, then the snap of his leather case.

Rage

In the morning, the Mandan boy has left, taking a horse and one of the expedition's food satchels. The photographer begins to curse. He runs into his tent to root through his luggage, to see if anything else is missing. He runs out to the Rambler and back, the pitch of his voice rising higher and higher, until he is almost squealing with rage. Upshaw ignores the photographer. He looks up at the sky before walking, wordlessly, out into the prairie.

Bait

"Did You Ever Try to Photograph an Indian?" in the San Francisco Sunday CALL, 1900: "There is just one feat more difficult than introducing an Indian to the bathtub, and that is, to make him face a camera. [But] there isn't any mystery about the methods of Mr. Curtis . . . His rule is an old one—'money talks.' It is with gold and silver bait that he catches the Indian and charms away his ingrained aversion for the camera . . ."

IN THESE PHOTOS, *no* resides: no clocks or watches, cars, cowboy hats, corsets, neckties, dungarees. No ankle boots, plaid shirts, wedding rings, trains, books, bicycles or newspapers. No highways, road signs, restaurants, groceries. We see villages, not reservations. No poverty. The camera draws a line between past and future, Indian and modern. Between Indian and not-Indian, even. Black and white only. No color.

This *no* extends inwards, to himself: To make the project seamless in its appearance Curtis never changes his methods. Though camera technology changes, though the art itself evolves, over the forty years he expends on the project he never significantly alters his style. The grandiosity and ambition of the project turns relentlessly inwards, stifling aesthetic development, so that the standards by which he succeeds as a compiler and cataloguer become the very standards by which, as an artist, he comes to fail. For all forty thousand exposures he takes, he chooses—he has to choose—what not to see.

Snake Dance

The photographer spreads the thick paste under his eyes, across his chin. The Hopi priest holds out the writhing, cool body of a snake. He takes it, and the body tightens instantly around his fist. He puts it to his face and the thing unclenches, coils around his neck. Seizes, twitches. He does not blink. In the dark of the kiva, everything is lidless, moving and tightening until the priest reaches into the bag again and hands him a rattlesnake. He puts the tail end of it in his mouth, pressing his tongue to the musky salt of the rattle as he grips the head tightly, the rest of the snake wound around his arm, moving like a muscle that won't stop clenching. There is a thick paste of corn smut and dirt along his calves and shoulders, which coats and darkens his skin. The sound of the snakes in the bag at his feet, and the feel of their dry slickness. The priests are speaking. They are chanting. They are moving as the snakes around his arm and neck tighten and release. They go out now, climbing from the kiva with the heavy bags of snakes jostling at their sides, all of them together, a blast of light, chanting, his own mouth moving and moving. Everything outside the ritual has begun to blur and dissipate: Clara, his children, his critics, Upshaw, each one like a black cloak falling away from him. All is smell here, and touch, and sight. He can smell the man in front, his dry sage scent; the clotted, blood-thick paste in his hair, the acrid burning of piñon wood. He begins to change, passing the snakes hand to hand, then back to the handlers, dancing, so many in the circle. The sun makes his eyes

hurt. He cannot see but only feels the snakes as they are handed to him, each one under his fingers like a ribbon of oil. He moves, his mouth moves. His mouth moves with theirs. The light around him: piercing. Around him, in him, everything slips into muscle: tightening, passing, tightening—

What He Wanted

Not to be merely an observer. Not to be on the outside of their beauty, but a part of their beauty. To be their preserver. To see these people bathed in grace, infused with nobility. That he should be a part of this nobility. And that, through these images, his own might be recorded. That this work should make him famous. No: that his fame should blend into, should disappear inside of theirs. That he should be equal to his sitters, not superior. That he should be seen as superior. That he should succeed. That he should be their familiar. That he should both see them and see through them. That, because of this seeing, his audience should love him.

Letters

The photographer is late with his newest volume. His tent is strewn with telegraphs from publishers and subscribers from Boston, New York, Seattle, reminding him of the fact. They are intermixed with Clara's letters with their pleading phrases, *out of money, if you would just return a month,* which pepper his sleep, along with his as yet unsent, typed replies: *If you would only trust me, you would see my project is that of a great man, and a great man should never be brought so low.* The words, thick and fast, pounded into the paper. *Do you think I am a failure?* He groans in sleep while his guide, Upshaw, dozes in his own tent, perhaps dreaming of his own wife, Emma. From outside in the night, the sounds of a young child, crying. *Am I a failure as a husband?* Unanswered, unanswerable, the fear of it trailing into dark.

PERHAPS THE PHOTOGRAPH, too, can see—alive
to what we make an absence, the history of the subject that
the image barely contains. The photograph sees both in and
outside the frame: Curtis's speaking engagements at the
National Academy of Sciences, the Rainier Club, the Indian
Welfare League. It sees him at his writing desk, before a rich
man's secretary, at the wedding of a president. It sees him
lauded, praised, excoriated, admired. It sees the raffish hat,
clipped beard, bottom lip like a strip of sheen and the pink
skin so smooth you cannot calculate his age. It sees the way
he grips the reins of his bone-white horse in one tight fist, and
how his eyes say almost nothing in comparison. It sees the
failures and the loss of money. It sees his guides attack him
for the pay he's withheld, with his assets liquidated, Morgan's
money gone, the Charles Lauriat Company telling him he
has to write the copyright for all his images away. It sees him
in the carpeted hallway of the Denver bone hospital where
he sits on a bench, unable to speak. It sees his months gone
by in whiteness. It sees both past and future—what he loves
being the same as what he fears. It sees Upshaw lying outside a
reservation, the knife slit deep in his side, blood freezing in the

snow. It sees the children, missing. It sees himself, missing.

Just as the photograph sees my father missing in the images of my mother and me. Sees the love he has for us mixed in with competition, the way the fact of my mother ghosts him in every photo I own, just as my parents ghost me, the shapes of my features—*Who do you look like? Who do you belong to?*—my name, biography, these small squares of writing in which only fragments can be pinned down. What registers? What won't let it? We close down and down in an attempt to capture one frame, one vision of the self, one autobiography.

TO BECOME CLOSE is to invite disaster. *I always thought your mother would divorce me and take you with her. Then what would I have had left?* My father told me this when I graduated from college. I don't know why he believed this was a possibility. Frightening—to love someone so plagued by his own anxieties, who ordered his life by such a rigid belief. Perhaps he was always this way. When the U.S. declared war on Vietnam, my father was among the first to enlist, telling his family that to serve the state during war was the cost of enjoying its benefits during peacetime. To my father, this was a fact of both citizenship and masculinity. He believed that as a boy and carried that belief over into adulthood. But later, while my mother prospered in her career, for long stretches he could find no jobs. For a long period of his life, my father saw himself as a symbol of the futility of his early idealism. And yet some part of him wouldn't abandon those ideals. The more fearful and disappointed he became, the more my father, as a man, would cling to his ideals.

My FATHER'S VISION of himself disturbed me. It didn't make sense that he could see himself as a failure. The first in his family to attend college and earn a Ph.D., my father was an astute and brilliant thinker who read voraciously, teaching himself the machinations of the stock market in the early hours before work. He was the one who successfully managed not only our finances but also the finances of our extended family, and even of my piano teacher. So what if he never became a professor? So what if, as he liked to point out, my mother made more money? I was, and am, in awe of my father's focus. And yet it saddened me to watch his dissatisfaction with modern America spill over into his understanding of gender and race. My father's anger troubled my sense of being half Chinese. It became a point of pride and sympathy with my father for me to pretend, like he had, that my race and sex would not matter in America. So long as I could somehow work outside of or against my appearance, my father's meritocratic idealism might survive. Because of this, for many years, I refused to speak about my mixed background. I told myself that I would succeed where he didn't in order to please him. What I didn't realize was that my refusal to speak about being mixed was not a negation of race at all but a silent place-holder into which others could insert

what they needed to perceive. In the end, I neither protected nor defended myself in my refusals, just as I did not bring my father closer. If anything, I negated my mother. And in the end, my reticence's only achievement was to make myself more of a mirror.

Light

I often wonder who you are married to—myself or to his project. Upshaw folds Emma's letter back into his pocket. He doesn't have to read the rest. He knows the lines by heart: *We have three children—I have had to take work as a laundress. Is this how you plan to support us?* The photographer is in his darkroom tent, preparing the plates. Upshaw can hear him humming and knows, from the sounds of tapped glass, the exact stage the photographer is at in the process. By now, Upshaw could go into the tent himself and stir the albumen mixture. Something about this thought, and the tone of the wife's letter, makes his eyes hurt, and he walks to his own tent to find a hat. He is reminded of a dream last night, his mother singing in their old apartment, dancing in circles on the floor. In the dream, she'd been calling for him to join her, but when he got close enough to take her hand, he realized that she wore his face. And when he looked down, he saw that he was wearing her polished boots, her white dress with the lace collar. A man's chiding voice shouted in the distance. *Light!* it called. *I need more light!* Upshaw turned to find his mother but

she'd disappeared: in her place was an iron pot filled with gold. He ladled out a small bowl of the gold and hurried toward the voice, tripping, spilling sun down his dress front. He watched it pool across the floorboard's cracks. A rush of gold filled the room, edging everything in light. Sun burst out of his fingers, out of his wrist bones. Still, the man's nasal voice called out for him. *Light! More light!* Upshaw staggered forth, shedding skin and hair and bones. He reached out to pour the bowl's remains into the other man's hands, but when he touched him, he saw his own fingers dissolve into shadow, the rest of him cracking, breaking apart with light.

Gold

A man stumbles up to Upshaw outside the Bighorn Restaurant, his lips and teeth stained dark. *I'm hungry,* he says, *I need you to feed me.* He says this in a language that isn't any language Upshaw knows; still, he understands him. *You're the translator,* the man says. *I've come to get my money.* He reaches for Upshaw's pockets, and suddenly Upshaw can smell it, the familiar sage and wax scent, and under that, the blood. This is his father, Crazy Pend D'Oreille. *I used to be a warrior,* he tells Upshaw. *I stole the Lumpwood's songs. Bull used to fear me!* He moves quickly towards Upshaw, and for a moment Upshaw can see the youthful figure of this man hovering around and over his stoop-backed shape. His fingers are long and hooked, his teeth sharp as an animal's. *Look,* the man says, *you're so rich your hair is even gold!* Upshaw raises a hand to his head and feels his newly cropped hair pull away, straw-colored in his fingers. Upshaw begins to panic. He looks down, and finds that there is money stuffed in his shoes and pants, spilling

out of his pockets. The man lurches close and Upshaw pulls back, striking at the man's chest and face. *Get away from me!* he yells. The man grins and pushes his face into Upshaw's. His mouth stinks of grass.

Winter, 1907

I hired you because you seemed educated, the photographer

scolds. Points at Upshaw, then to the Rambler. Vomit streaks

the side of the black car where the Piegan boy named Johnny

got sick. Upshaw had negotiated with him to be an assistant,

but Johnny has proved himself a drunk. The photographer

blames Upshaw. *It is your responsibility to watch the guides,* he

demands. *Your work is to keep them in line.* The photographer's

eyes are cat scratches in his face.

If it's my responsibility, then pay me, Upshaw replies.

No one's gotten anything for two months, the photographer

says. *You accuse me of not paying, but clearly you find enough*

to keep yourself in high spirits!

Upshaw scowls. He doesn't drink, and he refuses to steal,

though he knows others do so, selling off bits of equipment,

a blanket, or coffee, sugar, supplies they think the photogra-

pher will not need. This is the implicit arrangement they've

made: they steal from him, and the photographer pretends not to notice. Now, he has to notice.

The photographer kicks angrily at a tire. *Why should I pay for poor work?* he demands.

The other guides, George Hunt and Johnny, come forward. They gather behind Upshaw. He can sense their anger, which smells like the souring of milk. The photographer also senses it. He begins to sniff, voice cracking as he looks around at them.

You're a drunk! he cries wildly, though to whom, no one is sure. *Absolute savages. The lot of you are no better than dogs!* Which is the last thing he says before Upshaw lunges, punching at the photographer's chest, throwing him to the ground.

Letters from Curtis

Clara: of late I have had little but swats from my hometown and feel in a most disagreeable mood. Most of those who say good things about the work would if I owed them two and a half and could not pay on the dot kick my ass and say, Get to hell out of this. Yes, I will try to cheer up a bit but I am an unknown man trying by sheer bull-dog tenacity to carry through a thing that no one else cared to tackle. . . .

How much he's been told that he should hate himself for what, continually, he cannot accomplish. The photos, the unwatched film In the Land of the Head Hunters, the listless "picture-musical" he arranges from his slides: what is this body of work beside the actual bodies of those he cannot preserve? The raging. The desperation. The depression. The knowing he is being watched. The knowing he cannot ever entirely fit the form he has set out for himself.

If you hear anyone say I am not to succeed tell them they don't know me. I am not going to fail and the sooner the whole 'Damn Family' knows it the better. To fail in keeping my promise . . . will mean failure, and I do not care at this stage of the game to have the croakers say I told you so.

The Work He Loved

It is not enough to say that he destroyed himself with the work he loved, nor that he continued to love the work that destroyed him. After a time, perhaps he had no feeling for what he did—only purpose, which can seem like love. In court, being sued for more than $4,000 in back payments for child support, he is asked by the judge why he continued doing work he wasn't paid for. He breaks down, sobbing. *Your honor,* he says, *it was my job. The only thing I could do which was worth doing.*

Belonging

The short temper, the flaring anxieties. The lack of sleep, the slow way he would move himself around the house, staring at his wife, his child, people he knew but couldn't recognize as belonging to himself.

READING ABOUT HIS PROJECT, I criticize Curtis for getting any part of these pictures wrong. But it was not easy then—though it may be more so, now—to want to identify American Indians as deserving of compassion or respect, as Curtis believed. To imagine ourselves as connected to their history, if not in part responsible. Now, perhaps we look at these pictures through the lens of cloying self-congratulation. We empathize because the photos are beautiful. Because we think we already know the story. Perhaps this was what irritated my father the day I came home from school bursting with pity for the Sioux. His disgust was for my endorsement of any one group as victim or perpetrator, an act of condescension towards the Sioux that he feared would eventually destroy my ability to think complexly both about them and history. Though of course, his anger might have been far more primal and prejudiced. Perhaps, at the root, he didn't want to think about the ways we are all, still, accountable.

I DON'T KNOW when I first became aware that my father's anger was a sign of depression, or that his intellectual interests were feeding his anxieties. One day when I was thirteen, he brought home a book on evolutionary psychology. *Look at this,* he said, and read me passages on selfishness and survival, chapters that described how female chimpanzees mate after choosing as their partners the most aggressive males in the wild. For weeks after, he referred to this book, speaking of mind and body each as a mystery that could unravel to its single solution: *here* and *here* were the reasons for where and why males failed, with that lack of gene, this foreshortening of chromosome. I'd go to bed dreaming of the body as a sack of sparks, a series of leashed aggressions that ran wild under microscopes. I could not entirely understand the science, but I distrusted the descriptions of the living bodies within these theories, how the creatures described there appeared both reactionary and calculating. I felt disgusted by the way that lionesses went into estrus after a lion murdered their cubs. *The male supports his own offspring this way,* the book explained. *The pride is pruned back for his specific genes to survive.* I told my father I wasn't interested. Meanwhile, my father kept bringing home more books. He called his reading: *The search for the weakness gene.*

I WANTED TO KNOW my father. But I didn't want to hear his theories of biology, how certain people were doomed by nature to fail or disappear. I didn't understand what he craved, nor how my mother and I could register at times as vacancies to him. *It's these minority groups that will ruin the nation,* my father railed at the TV, watching a news report on domestic acts of terrorism.

Minority groups? my mother replied, pointing at herself, then me. My father blinked. *What does this have to do with you?* he asked. My mother threw up her hands. Got up from the table as my father went back to watching TV. *Deep down,* the reporter announced, *it's clear these groups are terrified of modernity.*

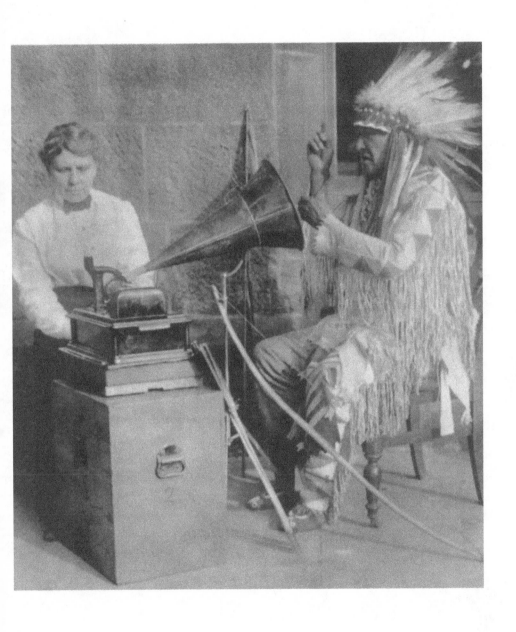

TO VANISH WITHOUT DYING: That was, of course,
what Curtis proposed for his sitters—a way to be living in and
outside death because someone else can see you. Someone
more powerful or right. (I almost wrote *white*.) What has to
be unseen, kept invisible, to make you dead to a culture? The
clothing, the language? The color of the hair or eyes? Can you
move to a city? Can five pots save you? Sixteen drops of blood?
Yes, the blood, kept in a little sanctified vial. In the end, how
scientific is this vision of race and life: that existence depends
on objects that are quantified, preserved, capitalized upon. The
human body on its own isn't enough to prove a life, let alone
a way of it. There goes Curtis: sick, dying, exhausted by life.
No one buys his books. In a month or two he'll have no wife.
The children are—somewhere. Else. The pain in his back. He
cannot breathe because of that pain. Two weeks in bed because
he cannot move, his body one enormous ache. The stabbing
difficulty of the light. It sears through every tissue of himself.
His eyes: he cannot close his eyes—

In the Divorce

The photographer's ex-wife, Clara, gets everything: the house, studio, equipment, all the plate glass negatives. Before turning the studio over to her, the photographer, his daughter Beth, and Upshaw will return to Seattle to print as many goldtones as they can, to copy some of the negatives out onto celluloid. Then they will take all the glass negatives across the street to the Cobb Building, pile them up and—either out of love for him or a sense of duty—smash them.

VI

*It is fashion to yearn for Nature, and to select her as bare,
bald and ugly as she is made, the particular kind being
that which is the outcome not of nature, but of the errors
of civilization. But when we examine the matter closely, we
find that no art to be successful, however it may try, can
entirely dispense with idealism.*

HENRY PEACH ROBINSON
THE ELEMENTS OF A PICTORIAL PHOTOGRAPH

*Only that which gives free rein to the imagination is
effective. The more we see, the more we must be able to
imagine. And the more we add in our imaginations, the
more we must think we see.*

GOTTHOLD LESSING
LAOCOÖN

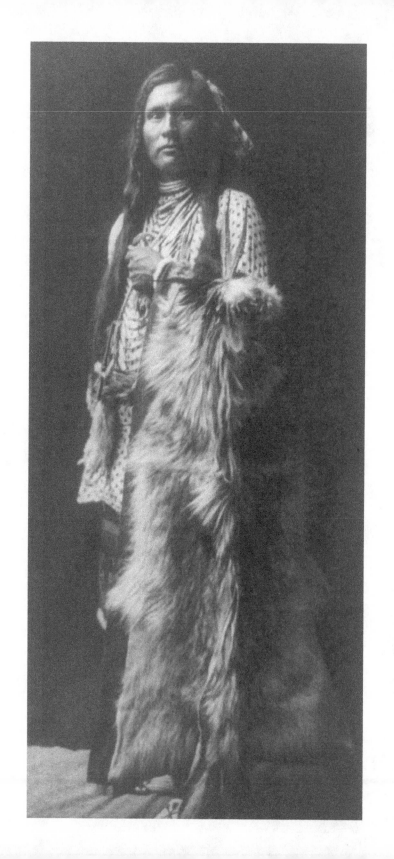

Edward Curtis's "A Young Nez Perce"

Sargent would have understood you, posed
like this: wolf furs carefully unearthed from storage
and slung across an arm, a cape of glistening grays
that shower to the ground. Your upraised
fist at first looks like a woman's breast half exposed,
so artfully do its knuckles catch
the light shimmering along the jet ridges
of your necklace quills. Below this,
long pants—shockingly voluminous—
dark as a gypsy's skirt; an ominous,
stately twist to your body that makes you appear
part politician, part dancer. So elegant an observer
with your cut-glass cheeks, you could be part
of any lady's sitting room, standing quietly alert
by the roaring fireside or the pianoforte, offering
us a glimpse of the kind of composure constituting
a character meant by birth to be observed, captured
forever by the very eyes you're meant to enrapture,
as you're all show, all gentled scandal now.
The way Virginie Gautreau
might herself have seemed, turned by the painter's
eye and hand to restive savagery: matte, black hair
and lead-white arms barely suppressed
by the dulling backdrop; flesh's glowing silhouette
snapped in by the waspish corset of a velvet gown—
Her sex, unleashed, might terrify; buckled down,
it's merely beautiful. As you are now.
Is that a human scalp hanging from your belt? We'll never know.
Some possum scrap, perhaps, a bobcat's tail, something
comfortably decorative—like the feathers trailing
from your hair. Jewelry we imagine "Madame X" might wear,
pinned to the insipid parlor couch as her blood lips sneer
into the semblance of a smile.
Something simple, rank and animal for us to wonder at—
to picture what it is you're holding back.

WE'VE GOT TO FILL THIS OUT, my mother says, handing me the doctor's questionnaire: CHOOSING YOUR END QUALITY OF LIFE. *Don't worry,* she adds, noting my expression. *It doesn't mean anything.*

She hits the button on the side of her hospital bed to raise it. She smiles at me and my father. *Let's spend a little quality time talking about death together,* she says.

I open the questionnaire and begin reading. *What do you define as basic quality of life?*

Shopping and eating, my mother answers.

That's all you do now, my father mutters.

What measures, I ask, *are you willing to take to preserve your life?*

Don't keep me alive in a brain-dead coma, my mother says. *Don't shock me with paddles. Tell them they can have all my organs but not my eyes.*

Don't give me CPR: they'll crack my chest! my father adds. *The doctor said you can be in pain for years after. And don't let them give me the expensive drugs. I'm not paying for any expensive drugs.*

Give him the cheap ones, my mother agrees.

So what do you define as quality of life? I ask, turning to my father.

If I can read and look at your mother's stock reports, my father replies. *Beyond that, kill me.*

I shut the questionnaire. *So essentially,* I say, rubbing my temples, *you both want to live exactly as you do now, or be dead. No middle ground.*

My parents look at each other and think a little. They look back at me. *Sounds good to us,* says my mother.

BUT IT'S NOT GOOD, TO ME. I hate this questionnaire. It reminds me that, regardless of my mother's condition now, there will be more X-rays tomorrow, then more tests months later. And years after, others. Each one providing increasingly difficult answers until no more tests can be administered, no other answers given. And while we celebrate the doctors' positive prognosis—*Looks good, perhaps two courses of radiation*—we are also reminded that all good news is temporary. In the hospital, watching my mother sleep, I feel time stretch and warp around me. She looks so like Po Po with her salt-and-pepper hair, her olive skin with its brown patches freckling the cheeks. It seems impossible to look at my mother and see only her, not also her future looming before us, an image indelibly etched in us from having watched Po Po struggle under her nurse's ministrations, weeping from the confusion caused by her medications, all while the rest of her family, exhausted, look

away. *Your mother is beautiful,* says one of the nurses coming in to check on her, but I've misheard this. What she's really said is, *Your mother is doing beautiful,* meaning she's healing well. But "beautiful" means nothing to me. What exactly is beautiful about my mother's condition? How hostile, to use this word for a body either healing or breaking down—we don't know yet; perhaps it doesn't matter, since at this stage it's doing both things at once—as if to dismiss the feelings of those who know that body as beloved, who see it as part of their own. I remember all the ways I've heard this word used to describe my mother, or my friends, countries, animals, or to describe me, and begin to hate it. Why did I ever think it was a compliment? All the while, this word was meant to silence the one being spoken of, to distance from the watcher the person being watched. To describe by not describing. As if my mother were a sculpture to be posed, a photo to be hung. What a

callow way of acknowledging her existence. The observer

looks and says: *I will come no further.*

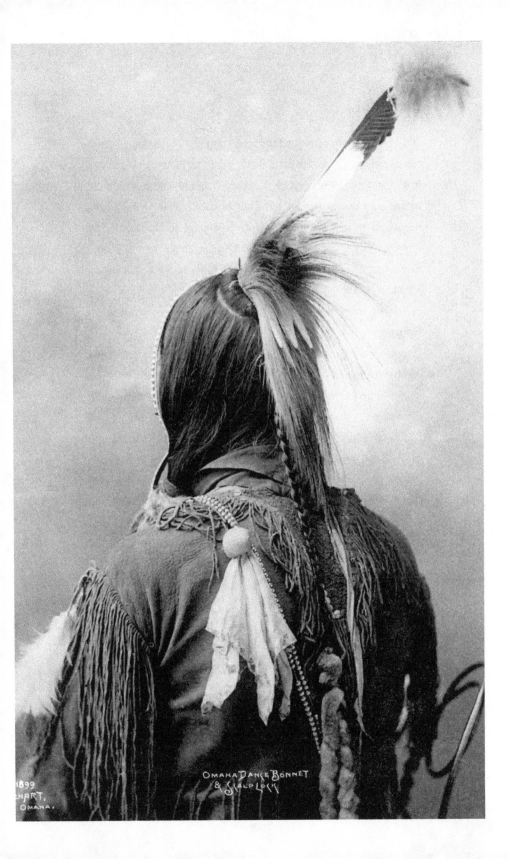

OMAHA DANCE BONNET
& SCALP LOCK

Beautiful

This is what J. P. Morgan had thought upon first seeing Curtis's photos. Standing in his office watching his secretary usher in the young man from the Washington Territories, blond and fair-skinned, wearing a wool suit a few years out of date. Talking even before he's asked to sit, pushing his portfolio forward with a little smile: *Mr. Morgan, you will not believe what you're going to see.* Which is what everyone says, Morgan had told him, adding at the end a politer rejoinder, *Thank you for your time*, as he pushed the portfolio firmly away. The young man pushed it back to him. *You have to look, Mr. Morgan.*

What had Morgan seen? Someone like himself: a man who wanted to make, to find; a man obsessed with what might be maneuvered, manufactured, manipulated. A man who believed in the relentless search for the new form. Or if not new, the exhaustive catalogue of the old. Did the two men, even at the start of this project, see the irony inherent here—the same lethal grandiosity, the same ambition to take hold of territories in the spirit that infuses the banker's and the photographer's impulses? To go backwards not forwards in time. Or by looking backwards, to project how far forward the audience will go. (*I take out the mothers, the horses, the young boys collecting berries on the hillside, the land, the buffalo. I take out the clock and the camera, which takes out the future—*)

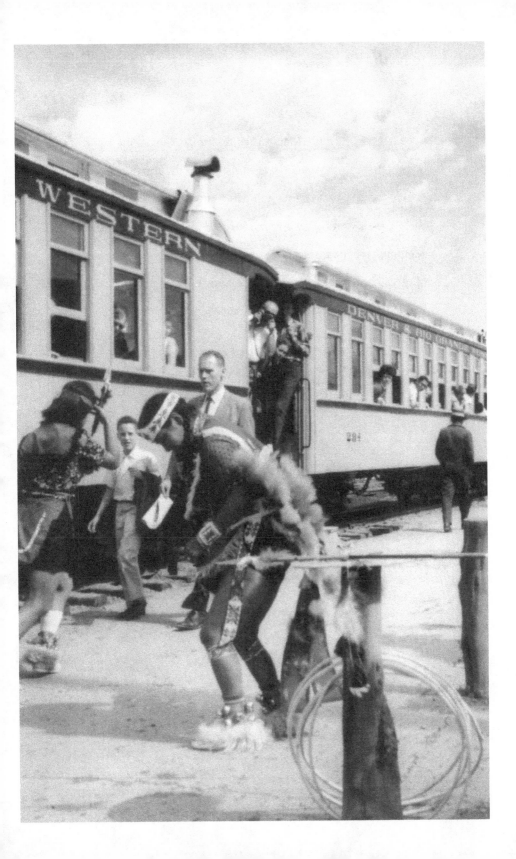

WHAT STRIKES ME NOW about the Curtis photos is how their beauty makes the vanishing of the American Indians seem not only inevitable but impossible to protest. (*This,* Curtis writes, *is one of the stages through which from the beginning the Indians were destined to pass.*) Though his sitters may be starving outside the frame, they look so attractive inside it: To be moved by their beauty replaces having to be moved politically on their behalf. As if without history, the photos take over the text Curtis wrote for his images and so isolate his subjects further in time. As if because of who these people are by nature, they were never meant to thrive. Curtis's pictures become a cult form of remembrance masquerading as science. (*Those who cannot withstand these trying days of the metamorphosis must succumb, and on the other side of the depressing period will emerge the few worthy survivors.*)

THE SUBJECTS OF his photos are mostly men. Yet why
do I think of these photos as being, at their source, feminine?
Is this because of the beauty of the images? Is it because these
images are supposed to remind us so forcefully of their subjects'
deaths? I remember a series of etchings I came across in college
of a young girl clasped in a skeleton's embrace: her firm, melon
belly withering in a grip in which flesh rots, desiccates. DEATH
AND THE MAIDEN. From these images I learned that women
are the embodiments of the best the body has to offer. We are
taught this since birth—every girl learns to understand this
innately. This is one of the reasons my mother used to shoo me
away from the bathroom mirror, scolding me for staring too
long at my reflection. *Forget beauty,* she warned. You look into
our faces and we see what you revere. We learn through your
gaze what will eventually be taken.

IN THE CURTIS PHOTOS, only women make things: the baskets, the pots, the rugs, the jewelry. That's where culture gets to reside: in the female bodies. The men are simply themselves—named, identified, labeled as types. They are personalities who live apart from their wives and children, who produce nothing but their names. What if the men had been photographed working? I look at them and note their strong, dignified faces, their empty hands, dulled knives. While the women keep working. I return again to the photos. The women do not look back at me.

WHEN LOOKING at an image, perhaps we see the
medium that produced it first. I judge my reflection by what
has recorded me: mirror, bowl of water, the plate glass of a
store window, camera. Perhaps we all do this. Drivers learn
to see a city through the car's windshield. We distrust the
actress's weight as she appears on television. And a camera
is our most important judge. I call someone attractive if he
photographs well. For my part, I freeze and cringe before any
photographer.

The Portraitist, 1908

So many years, working with the photographer. Upshaw now feels his mind can frame the image he wants and *click*, it freezes in his brain. Only a twitch of his mouth or shift of his body to register this change inside him: Memory has become an album he might leaf through at leisure, able to turn to any image as if it were a physical print. He can even change the image, create shadows so that a subject's face will scowl and age; he can put a spray of flowers in the hands of a passing child. Now it is his mother's face he returns to. Captured in profile, mouth pursed, one dark eye cocked towards him. Upshaw scratches out the youthful glow lingering in her cheeks, unravels the white lace collar. He takes out the black in her hair and turns it gray, imagines her shorter, fuller at the waist. He wants to make her old now, a crone who stayed with him in their apartment and never left. He was never sent to Carlisle. He was never sent away. His mother hums a song, and now he can see faint, raised scars along her hands and wrists. He blinks. He imagines more gray in her hair, sews up the frayed sleeve, tries to cover the raised scars but they won't go away; they stay there, wide and angry-looking: Why

have these scars appeared to him now? Had she mourned him after she left? His mother stops humming. Her lips part, as if to speak, and Upshaw begins to sweat. He doesn't want to hear what she will say. He needs to change the picture of her he's taken. He makes the bright sun seep into the color of his mother's skin until she's thirty years younger and he's six again, she's coming through the front door of their apartment, packages of other men's shirts tucked under her unblemished hands, colored threads stuck to her skirt hem from the tailor's. He hears the jostling of packages, his mother's low voice calling, and he smells sagebrush and horse hair, a faint trace of blood, *Alexander*—He looks and looks at the image. He changes the light around her.

Finding the Mothers

Upshaw is put in charge of finding mothers for the portraits. If possible, with children strapped to cradling boards or bound in papooses, packaged and propped, held stiffly aloft for the camera. *Find me babies,* the photographer begs, but babies are hard to come by. The children on the reservations are too old. The others have been sent away. The mothers Upshaw approaches retreat when he speaks to them. They find his clothes and manner of speaking awkward: they sense his strangeness, ask after his tribe to confirm that, yes, he too was a child cast off, then returned. The young mothers hold their babies tighter when he approaches. After a few months, however, he learns how to bridge this distance. He's begun to change. *We must remember our world as it is,* he tells the mothers. *We must do everything possible to remember.* He has begun putting on necklaces, letting his hair grow long. This change has been coming for a while, and now cannot be denied. Not long before, he had gone home to spend time with Emma, and at the café where he'd taken his family to eat, two white women had walked to their table and spat at his children.

That night in bed, Emma had lain beside him, stroking his arm while he seethed. *It's always been like this,* she reminded him. *You just weren't here to see.*

I've always noticed, he hissed. *But before, it only affected me.*

At home with his family before returning to the photographer, Upshaw had studied the books that still lined his walls, books from Carlisle and Genoa on English rhetoric, algebra, arithmetic. Sara, his eldest, had once thought she too would be a teacher and had taken to reading these volumes on her own, quizzing her parents about certain abstruse passages. He'd enjoyed that. But then Sara had grown and turned sullen, private, more interested in the possibility of living in town than attending one of the Indian schools. And then winter had come, lengthy and violent, and one by one the volumes had to be torn up for kindling paper. The first to go was Claire's manual on science. Emma had volunteered it, and Sara, to Upshaw's dismay, had torn the book up without protest.

In camp now, late spring, he writes Emma letters, reams of pages he never really expects she will answer. *Something must*

sustain them as adults, he lectures his wife. *I must move back and teach them what it means to be Crow. For that is what they will always appear to be, regardless of their mother.*

In Upshaw's portraits, his mothers look down at their children, arms curled around each bundled form. Hidden by stands of aspen or oak, surrounded by tall reeds that border streams, his mothers nestle into their settings, cradled by grass and tree and light. They wear their best dresses, their children beside them wrapped in skins, beaded with half-moons, roses, hunter's arrows.

And me—Emma's latest letter in return had questioned. *What am I to teach them in that life?*

You have a good eye, the photographer tells him. Upshaw shrugs. He goes back to posing his mothers.

Pryor Valley, Summer 1908

Our eldest Sara has had a fright, Emma writes. *Ranchers have encroached on Crow land—some as far as our cabin in Pryor—one of them approached Sara—she has just turned thirteen—*

The rest is blank. She can't say that the girl had stumbled to the cabin, one shoulder of her dress half-torn. Emma had been at the washbasin when she'd rushed in, Sara almost throwing herself at her mother. *There's a man out there,* she'd told Emma. *He said he was looking for his calves. He asked if we'd stolen them.*

Emma had wiped her hands on her skirt. *And why would he think that?* she'd demanded. *He said Indians were stealing his cattle. Then he grabbed my arm,* Sara had panted as she tugged at the torn shoulder of her dress.

Emma had looked at her daughter. Long, fine hair, and sallow skin that browned too quickly in the sun. She had her father's height and coloring, but her mother's features: wide eyes and a mouth that reminded Emma of her own Irish mother. Emma could see faint thumb-marks bruising the side of the girl's cheek.

Did he follow you? she'd asked. The girl kept her eyes down. Emma told her to go sit with her brother and sister by the fire, then walked outside then and stared down into the valley. If the man were coming, he would bring others. She'd calculated the hours between the cabin and Billings, the cost of even one night in a hotel. She looked at the rancher's place lower in the valley and recalled the hostile looks in church the rancher's wife had shot her. *At least here,* she thought, *if more trouble is coming we can see it before it arrives.*

That night, after dousing the lights, Sara wriggled in bed beside her, whispering so as not to wake her siblings. *I want to live in town,* Sara said, as if she'd known her mother's thoughts. *I want to live in Billings.*

We can't, Emma replied.

Then what about further into the Crow lands? Near the Bighorns?

We can't, Emma repeated, dully. She rolled onto her side and told her daughter to hush. She listened to Sara listening

to her in the dark, recognizing the false ways she'd deepened her own breathing to pretend sleep for her daughter.

As soon as you are able—return, Emma writes in the morning. *You have left me with no money or security—no instruction—I am afraid for our safety in the valley—I am afraid what might happen in your absence—*

Outside the window, Emma can see Sara direct the children in their chores, watching as she clucks at them not to stray too far past the porch. She watches her daughter scan the horizon, her own eyes squinting in sympathy when her daughter's meet the sun. Sara, sensing she is being watched, turns to look at her. The shoulder sleeve of her dress is still torn.

In the Bighorns

I'm finished here, Upshaw spits, hauling out the spare tire from the Rambler's trunk. *I've had enough.* One of the front wheels has a puncture and the back window has been smashed. Another act of vandalism. They'd parked the car on a hill outside Medicine Trail Coulee, ridden to Little Bighorn on pack horses with Custer's erstwhile Crow scouts White Man Runs Him and Goes Ahead, Hairy Moccasin and Curley. The photographer, sensing their presence here has been noted, blames the vandalism on a passing Sioux or Cheyenne.

White Man Runs Him still has enemies, he tells Upshaw, inspecting the spare. *You know how territorial these old warriors get.*

It could have been whites, Upshaw mutters, hunting for the jack.

It could have been whites, the photographer agrees, but the tone of his voice suggests that he thinks otherwise. Upshaw bends and wrenches at the wheel. He's sick of it, these other men's words still churning in his mouth, the stories the scouts told slipping in his mind. Curley's in particular had sickened him today, the too convivial way he'd traded hats with the

photographer as a joke, cutting his eyes at Upshaw while recounting his days with Custer. Too many inconsistencies in his story; Upshaw couldn't translate them all, and had kept trying to pin down the facts in his mind before retelling them. When they'd gathered to eat by the fire later, Curley had looked at Upshaw, pointed to White Man Runs Him and said, *Maybe Upshaw should have his name.*

Upshaw had grown quiet, filled with a sudden, violent emotion. It is the same feeling he has now, glancing over the car. *Doing this work comes with a cost,* the photographer reminds him, and Upshaw startles to see—from the strange glow in the man's cheeks as he surveys the damage—the photographer seems proud of their troubles.

It's not a good thing, Upshaw replies. *We should have at least achieved something real for the pain all of this requires. Something that benefits us.*

This does benefit you, the photographer says. *It will benefit all of you.*

Upshaw looks at him. *I don't want something for everyone,*

he says. *I want something for my family.*

That's a tribal attitude, the photographer scolds. Upshaw gives the last bolt a vicious tug, gets up and packs away the jack. *Better to be part of one tribe,* he tells the photographer, *than no tribe at all.* He cranks at the engine and the car starts. The men get in and it stops, jerks, shudders a few feet down the hill.

We should have stuck with horses, the photographer says as his foot pumps at the gas. He stops, cranks the accelerator. The Rambler coughs again, starts, then gives out, and the two men feel themselves sliding backwards.

VII

And I ride to the valley of the brave Navajo, oh, oh—
Oh! Oh! a vanishing Navajo, oh, the vanishing Navajo—

JOHNNY CASH
from the song "The Vanishing Race"

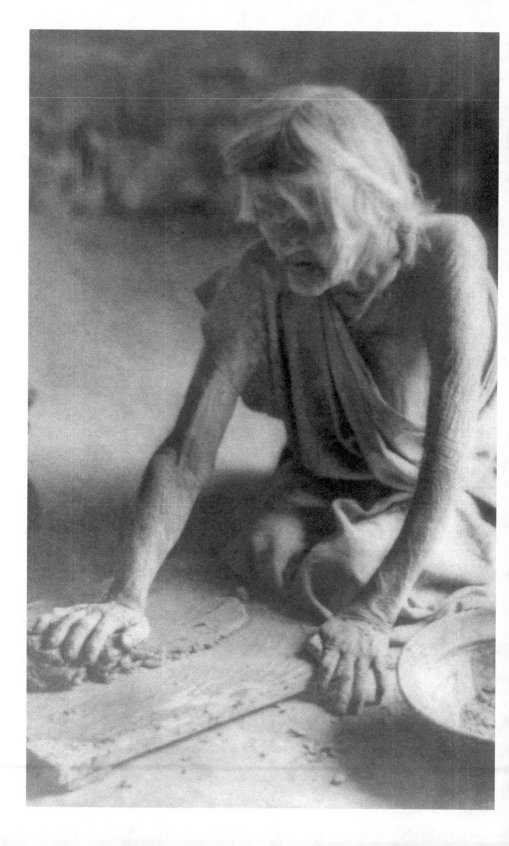

Edward Curtis's
"The Potter Mixing Clay—Hopi 1921"

Cracked fragile, powdered clay, like she
but no she: breast hanging ruined
in its simple shift, color of mud or shit, color

of clay she gropes at, blindly, massaging into light
some future shape, some life-
like thing darkly waiting
to be recognized, Graeae isolated

from her other selves, the eye

passed back and forth and thin skin stretched
to ragged strips as she is and is not

thrown, fired, pressed

beyond the pale saint's garb; hands

so large they might be paws. One task, one
thought: to be beyond beauty,

beyond praise or identity,
made and made and made again, to be

(*if a ghost carried over your future*
would you recognize it?)
body stripped of body disappearing
with its art but now the art

that stays, resides, that turns its face *away from,*
that constantly defies—

My MOTHER LOOKS over at the Curtis book. *What are you reading?* she asks sleepily, and I show her the photographs. *Oh, sure,* she slurs. *Your father has been looking at those.*

I don't know why, I say, suddenly angry. *They aren't very authentic, you know.*

What does authentic mean anyway? my mother replies. Closes her eyes. *Who has the time to care about authentic?*

She drifts off to sleep. I look back at the photos. She's right, I see. We don't have the time. The photos are here now; my mother is here now. I want these images to be authentic because I think authenticity means a condition of being that will not change. Because I want not to change. Because, when I see my mother drifting in and out of her anesthetized sleep, I'm frightened to see how her whole self is simultaneously coming into being and degrading.

So IT'S NOT AS IF the photos shouldn't exist—imagine, that final erasure. It's not as if there isn't a culture that can be recognized there, identified and described: Ojibwe or Diné, Hurok or Apsaroke. But to see those cultures through the lens of Curtis's nostalgia ignores that at all times we change: The prayer develops an added word, the favorite song loses a particular embellishment. Skin darkens, lightens, darkens again. Assimilation always occurs, even if only from within. To enforce change from the outside maintains that what's within cannot itself evolve. At some level, to insist on an authentic identity the way that Curtis has is a form of violence.

Thinking this, I recall how, faced with the strange and frightening changes to his country, my father's politics grew teeth and claws: the snarling letters to the editor, the little cloisonné flag permanently attached to his lapel. Once at a party my mother threw, someone suggested the bombing of the twin towers might at some level be historically justified, and my father left the table, shouting. A patriot—one who deeply believes in the authenticity of his nation.

The Battle of S...

LIKE MANY third-generation Chinese Americans, I am completely assimilated. I do not speak my grandparents' language. I understand only a smattering of its phrases now and likewise little of their customs and traditions, blocked from absorbing fully a culture that might hinder me from entering what my grandparents—through the inherited assimilation of my mother and uncles—saw as America. Po Po and Gung Gung's deaths cemented this. But if I do not meet the requirements of Chinese authenticity, neither do I always meet the requirements of mixed-race authenticity, if appearance is that identity's defining factor. Strange facts, which other mixed-race people may have noticed as well: the face changes shape, the hair changes color. Some start looking more dark, whereas I've become more white. Many people are surprised to hear about my mixed ethnicity, though many others aren't. Either way, I cannot seem to think about myself without thinking of this slice of me that remains absent, persistent and obvious yet invisible. I cannot see myself without seeing first my audience, those who are seeing me.

A CASE IN POINT: When I was employed by the University of Wyoming, they wanted to take my photo. The day of the shoot, I wear a black sweater, dark purple skirt, long black jacket. I am asked to take off the jacket. I am asked to step away from the teaching blackboard. I cross my arms, smile slightly, am told to put my arms at my side. Photos are taken. I am told to sit in a chair, pick up a book, to put it back down. I am told to take my hair out of its clip. Photos are taken. I am told to smile and pick up an apple. I am told this is for a joke. Photos are taken. I am thanked and asked to leave. I put on my jacket. I scrape back my hair. I leave to go and teach.

TWO MONTHS PASS and now my photo is on the Wyoming website, the student directory, the academic calendar. I am standing half in profile in an apparently flirtatious manner, long hair down. One hand rests on my hip. The other is raised almost to my shoulder. I am smiling. I am offering the unseen viewer (you) an apple.

Later, the photo is retouched for a spring theme. A violet halo surrounds me. Instead of an apple now, someone has digitally inserted the image of an enormous orchid onto my hand. With my long dark hair and purple skirt I look, as my father says in an email, *like a Hawaiian Air stewardess.*

I ASKED THE UNIVERSITY officials to destroy the photos, even burn the negatives. When I asked whether they knew I was mixed race, the editors insisted that they didn't. They certainly hadn't asked—I remembered that. But what did they see when the photographer brought them the series of negatives? What did the camera reveal that the eye, on its own, did not?

CASE IN POINT, TWO: Whenever I talk about the Edward Curtis photos, people ask if I'm Native American.

IN PHOTOGRAPHS, when I turn my face to the right, I look more Chinese. When I stand in profile facing left, I look white. My friends have noticed this as well, examining a series of book-jacket photos a photographer sent to me for selection. In person, I don't think the ambiguity can be noticed, since a face changes its expressions so quickly, thus the person looking at the face constantly accommodates and returns to what she remembers of its appearance. The eye knits together what the camera recognizes as divided in the body. Note the photo of the friend whose right eyebrow seems suddenly so much higher than the left, the tooth that strangely juts, the smile that turns down now at one corner: We see, but do not see, these details in person. In person, we see each other's emotions and thoughts as they are registered through the body. To a certain extent, it's as if the body doesn't entirely exist. But the camera knows that it does exist. The camera looks, solely, at the body.

BEAUTIFUL: In Plains Indian sign language, pass a flat right hand downwards over the face; make the sign for Good; or hold the hand up like a mirror.

Sign Language, 1908

Upshaw sits in the Cheyenne camp beside Harold, son of the photographer. The boy is a teenager. He, too, wants to become a photographer. He is constantly underfoot in camp, asking for his father's or Upshaw's advice, trying to get the rudiments of sign language down. Upshaw does not mind teaching him. Harold seems apologetic for his curiosity, and for some reason this makes Upshaw warm to him. Upshaw watches Harold now as he tilts his head, squints an eye, puts his fingers up in a framing gesture the way he's seen his father do. He has the photographer's blond hair and narrow eyes, but a smaller chest.

He smells smoke from a campfire that's been recently put out. From behind him, Upshaw hears giggles. Upshaw shifts slightly and turns to find a couple of Cheyenne women. They point at Harold and begin to sign. *Handsome,* one woman says with a sign, using her hand like a mirror, pointing to the boy's face. Harold smiles and looks down at himself, his long legs like his father's but thinner. His face is wind-burned, barely able to grow a beard. *Married?* The woman's hands ask. *You*

and your father look lonely. Harold turns to Upshaw, who translates. The woman whispers something to her friend and they laugh. She has a small, wizened face that reminds Upshaw of a fist. She looks him in the eye, tilts her head, and he notices for the first time the long scar at the base of her throat. Upshaw looks away. The woman smiles at Harold, signs, *You two should wait for my daughter. You'll like taking pictures of her.* Harold, only half understanding, blushes. The woman's fingers swirl in the smoky air.

MY FATHER and I sit at the restaurant bar, late afternoon. We have just come from the hospital after a third day of visiting my mother. We sit drinking wine and arguing over the one subject that will help us forget the visit: my taxes. We are so absorbed in the argument that we don't notice the bartender a few feet away from us, uncorking a bottle, staring. My father is in his early sixties but looks younger. I am thirty-five. I have almost black hair and eyes, and my hair is loose and drying from the rain outside. I am wearing a skirt and a cardigan that, due to the restaurant heat, I've partly unbuttoned. The light in the bar is turned low. My father leans toward me, into me, his face and hands antic with emotion. He is extremely upset about my mother. He jerks his glass to make a point and wine sloshes out of his glass onto the counter. The bartender starts to edge over protectively. *Dad,* I say. The bartender startles. My father, noticing him, looks up. The bartender moves away again, looking from my father to my top, my skirt, my dissimilar hair and eyes, the wine that's spilled on the counter. *Oh,* he says. My father looks at me and looks. He flushes.

Pornography

How long have you two been on your own? This is the question the photographer and Upshaw are occasionally asked by women, but Upshaw never wants to answer. The implications unnerve him. The photographer, by contrast, seems to have no needs outside of work. *I am married to this project,* he tells Upshaw. After two years together, he changes this "I" to "we": *We are married to the work* . . . At night, thrashing in sleep, Upshaw dreams of Emma's pale arms and legs. He takes long walks, sometimes swims in a local river. Meanwhile the photographer retreats into his tent. One afternoon, outside Billings, they stop to buy supplies at a general store, and Upshaw finds a trinket nook tucked into the back of the shop. He finds postal cards for sale there, one with a photo of a young Mojave couple. The couple appear to be close to his daughter Sara's age, around thirteen years or so. The boy wears only a thin piece of cloth around his waist, the girl a full-length flowered skirt that seems more like a tablecloth than part of a dress. The girl has full breasts and light-colored eyes. She stares at the camera while the boy, gripping her around the shoulders with one arm, looks away. Perhaps because

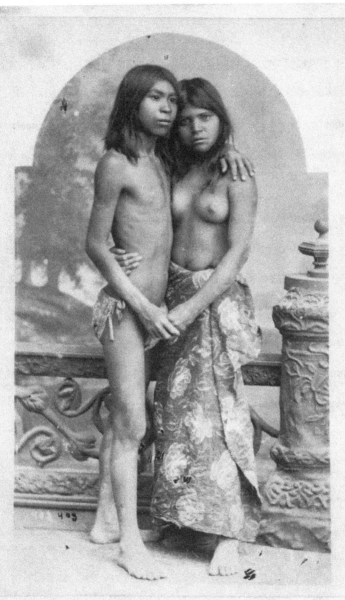

ARIZONA ILLUSTRATED

—BY—

H. BUEHMAN, TUCSON, A. T

of those milky-colored eyes, there is something even more naked about the girl: Upshaw can't stop staring at the girl's intense face as he stands in the shop, flies circling his sweaty neck and collar. The girl looks—Upshaw cannot come up with a better word for it—conscious of herself. A dim breeze drifts past, stirring up the scent of dust and the greasiness of hair. A shadow coughs behind him. Upshaw slips the postcard back into its box. He turns, and the shadow becomes the photographer. *What have you found there in that box?* Curtis asks pleasantly. Upshaw shows him the picture. The photographer looks at it, then stares at Upshaw a long time. There is an expression on his face that Upshaw cannot read. *Pornography,* he finally says to Upshaw, and tosses it back into its box.

Scar

You'll like photographing my daughter, says the voice in his dream. Upshaw circles a dark lodge, trying to find the source of this voice. In one corner, he finally sees a woman with a long scar across her throat beckoning for the photographer and Harold to come join her. She wears a winding sheet and has a bone needle in her hand. As Upshaw watches, the woman bends down to a pile of animal skins at her feet. She picks them up and, one by one, begins rhythmically to stitch them together. The pile of skins turns into a dress, with a mane of hair. When Upshaw gets close, he sees that the skins she's sewing aren't animal skins but human flesh. The photographer takes out his camera. The needle bites into the folds of flesh, the shadow of her hand upon it like a seam of blood. Upshaw crouches and sees his face emerge from the woman's cloth. The woman smiles at the photographer's son. *You can marry her,* the scar mouth says. The photographer raises up his camera.

How not to see that part of the beauty of Curtis's photographs might also be sexual. If his subjects had some secret way of life that they'd preserved, some native Indianness radically different from native whiteness, why would this difference not incorporate every aspect of their life? Indian women have to be different from white women. And the beauty they possessed must also be sexual beauty, expressing a knowledge specific to them and, naturally, to the men they took to bed. Through their female bodies, Indian women could make Indians of anyone. To Curtis and his contemporaries, this would have been terrifying and titillating at once: to imagine that the essence of race might not just be appearance or blood but also experience, which could be spread, shared, learned. Anyone might be initiated.

Snake Dance

Curtis can smell them before he sees them. The white tourists, one with his wife in full corset. Her hands are tucked into thin leather gloves that she smoothes and smoothes over the rustle of her skirt. He can smell her hair grease as he lingers in the kiva, looking. She raises up her camera. Its dark, brooding face points at the man in front of him. The man moves, both revealing and hiding Curtis's own position. His blond hair glints in the sun. She stares. Someone puts an arm on his shoulder. He moves. Sweat runs down his arms. She raises up her camera. He sees her looking at and through him. He moves towards her. She raises up her camera.

PERHAPS THIS IS the other reason Curtis didn't photograph mixed children: All his readers would see when looking at these portraits would be the acts, the marriages, that made those children. To look at a photograph of a mixed child would be like looking at pornography. A form, perhaps, of vicarious participation.

WELL, THAT WAS AWKWARD, my father says as we leave the bar, slightly stumbling, a thin rain slicking the pavement. We stand together in the rain at the bus stop. I watch my father dig in his briefcase for an umbrella. He gives up after a minute or two, and we back against the building wall for shelter.

Your mother and I used to get looks like that when we were in Paris, my father begins, then stops. This is the most he's ever said about the early days of their relationship.

You got those looks when you came to visit me in Ireland.

We got those looks almost everywhere, he says. *Not now so much. All that's changed.*

That wouldn't have changed if mom were black.

My father looks at me. *Why would mom be black?*

Forget it, I tell him, but he's already geared up for another argument. Debate, I remember now, is my father's form of exercise. The bus comes and we get on it, bickering with each other all the way home about why my mother isn't black.

WHAT WOULD my mother recall of the early days of her marriage? A memory: walking into Po Po's living room crowded with Chinese matrons from church, my mother stammering when asked to speak. Or: watching her walk a few paces to the side of my father, pretending they are not together. At the hospital, four days after the surgery, she even develops a little joke. When the attendant who is dressing her asks if I'm her daughter, my mother looks at me, smiles, and tells her—*No.*

HALF-BREED: In Plains Indian sign language, place one palm over the breast, move it directly ten or twelve inches to the left and back again to the center, then move it directly ten or twelve inches to the right.

No, MY MOTHER'S JOKE about our relationship
did not develop suddenly in the hospital. She has done this
before, once or twice since I was a teenager. I don't want to
imply that my mother doesn't love me. Even as a teenager I
understood her negating answer had nothing to do with me.
When strangers ask if I am her child, they are not looking at
me but thinking of the man who, though invisible, is the one
who made me appear so different from my mother. When my
mother says I am not her child, she is trying to deny that she
made a decision to marry someone not Chinese. I am at best a
symbol of something she fears about herself. This symbol, even
though it is me, is something over which I have no control.

BUT OF COURSE, although I say I understand this, I do not really understand. I remember very clearly standing next to my mother's white and rumpled bed at the hospital, looking into her face as the attendant asked her question. I remember the swift, almost fierce delight in her eyes as my mother looked at me and said *No.*

WHAT DISAPPEARS? I'd always thought my father was
the one who, disappointed in his ambitions, felt invisible
in the America he'd envisioned. Now I see that my mother
has also considered herself an absence. Is this marriage? Or
another way that race wears us down? Or is it some new
consequence of my mother's illness? I used to wonder if,
had I looked like my mother more, I would have been more
hers. If so, perhaps she could have imagined that she'd also
preserved more of the language, more of the reality her own
mother had experienced, if I were entirely Chinese. Could
she love me more, if I looked like her? What if I were to look
so different from her that I would be the secret dream that
some Asians still crave, must teach themselves not to crave?
A dream that I recall having, as a very young child: myself,
standing in a boxing ring where my mother paces, directing a
team of scientists. Blood everywhere—on the mat, the walls,
the ropes of the ring. My mother is pointing to pink buckets
filled with pieces of children. That arm, she tells a scientist,
pointing. And that one's eyes. He reaches into the buckets,
pulls out the requested items. He begins to sculpt and
stitch a child together with blood-speckled blond hair and

blue eyes. I stand by my mother, begging her to stop, to turn around, to look at me, but it is as if she can't hear. She pushes past me and stands before the child, appraising it carefully. It is another little girl. My mother reaches out and strokes the pale face. The child stares back at her blankly.

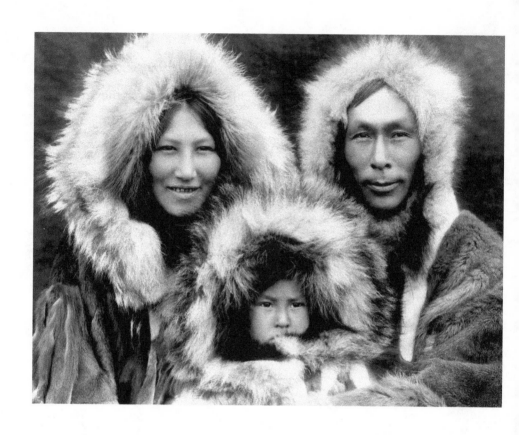

The Girl Who Married a Ghost

—from the Nisqualli tribe of southern Washington,
adaptation of a translation by Edward S. Curtis

Once there was a rich man with three beautiful daughters, the eldest
so beautiful that all the young men wanted to marry her. But the rich
man refused them all, angering them until one put a curse on him: *Let*
the ghost people come and carry off your daughter!

One night, from the ocean, fog rolled in, carrying with it canoes
loaded with skins and oil and food: the party of a bridegroom so rich,
the father could not refuse to give up his daughter to the one who
asked for her. She left with her groom that very night, over the water,
traveling until they came to an island so filled with night that every-
thing was black. Still, the girl could see without difficulty. *Strange,*
she thought, and watched as groups of people worked and played,
charmed by their greetings as her husband led her to his house.

They spent the night there together, but in the morning she awoke
to find a skeleton beside her, gleaming. Terrified, she leapt from
bed to run outside, finding the once-bustling village now nothing
but bones: skeletons of women, children; skeletons of warriors she
kicked to pieces as she ran, each one in tattered clothes; the formerly
beautiful lodges now ruined by the wind.

The girl sat down and cried until Screech Owl heard and came
down, comforting her with the news that all would be well. The mis-
take was hers for waking early, Screech Owl said. In the land of the
dead, people lived with the rise of the moon.

So the girl stopped crying, and walked around putting back
together the bones of those she'd scattered according to Screech
Owl's orders. Then she waited for nightfall when her husband's peo-
ple would wake, as alive as they'd seemed before, and lead her back
to her husband, where she would stay and live happily beside him.

In this way the girl lived with the ghost people for many months until, one day, she gave birth to a son. At that, the ghosts became uncomfortable, with the arrival of a child neither properly ghost nor human, and they insisted she take him back to her earth home to be raised. Before she left, however, they gave her a warning: Do not unwrap this boy from his cradleboard for twelve days or he will change and have to be returned to his father.

For eleven days, the young woman watched her boy closely, shredding moss and cedar for his cradleboard, but on the twelfth day she went out, leaving the child in the care of her mother. Curious to see how her grandson was different from other children, the grandmother unwrapped the boy and found, to her horror, that he'd changed to nothing but bones. The young woman came home to find his bones scattered, and she wept as she put him back together, knowing then that the two of them could never return to earth.

That night, the ghosts paddled back for her and the child, returning them to the land of the dead where they forever became ghosts. From that time on, no living creature has traveled to that place or spoken with them. No creature, that is, but Screech Owl, who flies back and forth between the two worlds whenever she chooses.

She does not reveal herself to us in human form, nor will she speak our language, though sometimes at night we hear her cry or watch her shadow wheel past the smoke hole.

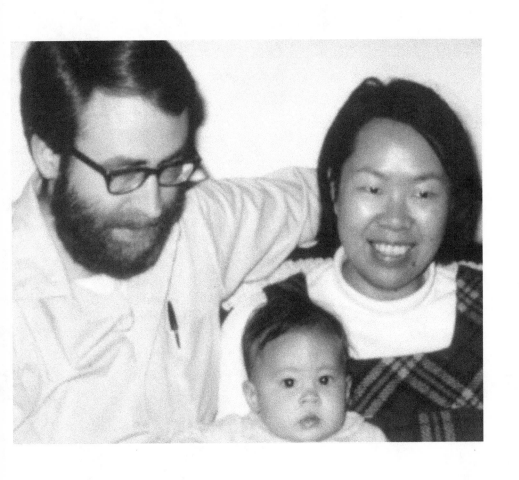

VIII

*The photographer projects himself into everything he sees,
identifying himself with everything in order to know it
and to feel it better.*

MINOR WHITE
"The Camera Mind and Eye"

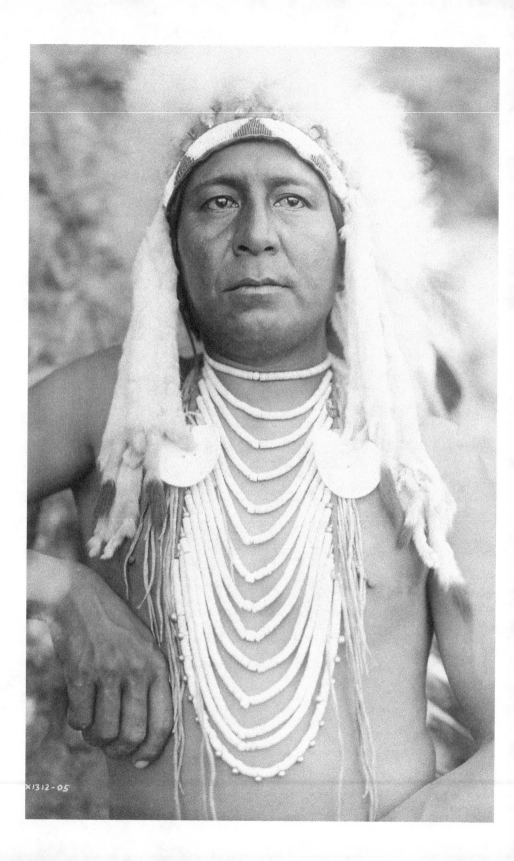

Portrait of Alexander Upshaw

With God's grace, the photographer says, *I might scrape by without you.* He is preparing to take the last portrait for his volume on the Apsaroke, or Crow, and Upshaw himself has been chosen as that series' final subject. This is meant to honor him, as the guide has decided to join the tribal politician Plenty Coup in the Apsarokes' fight against the federal government. In the spring, Upshaw will leave the photographer.

The photographer arranges the white feathers of Upshaw's borrowed headdress. Bare-chested, wearing only a necklace of polished abalone shells, Upshaw shivers slightly, and he tells the photographer, *I want to face like this.* He turns to the camera. And yet refuses to look into its lens. The pose, including the clothing, is Upshaw's choice. But this fits with his project, the photographer thinks, noting the way Upshaw's face seems softened by age, the skin darkened under the white feathers, the way Upshaw's father, Crazy Pend D'Oreille himself once looked. Upshaw had seen a portrait of his father last year in an old shop catalogue, and he told Curtis to make one just like that. *I want to look like him now,* he'd told the photographer. As if recalling that conversation, Upshaw straightens into his pose, and now Curtis sees the shape of the older portrait shimmer over Upshaw's features. For a moment, Upshaw becomes one of a line of men and photographs branching out, bleeding image after image into each other in the photographer's mind till they become both too similar and too distinct at once. Together, these images begin to compose a family of the missing, a single body that Curtis had imagined he might stitch together through his work, the way he once imagined he might join himself with Upshaw's cause. Curtis could speak, and the Indians

would listen, while looking at Upshaw, imagining the information coming from his own mouth. Or was the process always just the opposite?

Light swells in the sky, glows through the faint wisps of the white feathers. The photographer looks down, sees Upshaw's dust-spattered dungarees, shoes cracked and stuffed with newspaper. What if he backed up, further, taking in the whole of the image? Something in Curtis's stomach twists. He stands up and shuts down his camera.

We're finished here, he tells his guide.

Pryor Valley, September 1909

At home, Upshaw wakes to find mist covering the valley floor. Fine nets of dew have beaded in the grass, stringing themselves on the fence poles behind his house. He pushes himself slowly from bed to go stand by the window. Fog outside collects, then thins. A dark shape hovers behind it. Upshaw pushes his face to the glass and peers out. A small girl rises before him. It is Not Rachel, her thin legs bare and arms swinging at her sides. She walks to Upshaw's window, her long hair thick against her shoulders. She turns and makes a face at him, a face like one of his children would make in play, half like a smile, half like a sneer, then she turns and runs away. A sharp whooping accompanies her. Upshaw watches as she passes through fog that swirls open then swallows her, the girl's shape hovering over the ground.

TO UNDERSTAND the Curtis photographs is to begin understanding all the ways a person disappears. From the body, out; from the work, in. Something always vanishing: I think the photographer was obsessed with death, I think all his pictures are portraits of that. The long field opened up, absent of wind. A dark figure steps across to where a hangnail moon rises over the corn. *Where are you going?* a child calls. But the figure keeps on walking, pushing further into the dark. It walks purposefully on, away, as if that were the place it had always belonged.

Away

And away is the place the child goes, too. By the end of Curtis's life, the photos he has spent four decades perfecting no longer captivate the nation. His books go out of print, his career turns into work at a Hollywood studio making photo stills. Then this work, too, disappears. Publicly, his children support and adore him. Privately, they each begin to wonder if his photos aren't like the Indians themselves: a flicker of light, a scrap of shadow, then finally dark.

November 1909

One night, on a routine walk along the edge of the reservation, Upshaw passes the bar half a mile away from his home. A man staggers out, muttering, drunken. His face and body are covered with a blanket. He veers straight towards Upshaw, nearly knocking him to the ground, at which point Upshaw scolds the drunk, first in Apsaroke, then in English. The man rears back but keeps the blanket tucked around his face. *You're the translator,* he says. The man's mouth is black. He crooks a finger towards Upshaw and Upshaw pushes him away, the man falling exaggeratedly onto his back. Upshaw walks. The man heaves himself up and moves for Upshaw. He is surprisingly fast. Upshaw turns too slowly to stop him, and now the man is punching him, light-footed, all his drunkenness shrugged off him like the blanket. Upshaw can see—in the sudden slips of moonlight—that the man's face and hair aren't that of a Crow. The man jabs left, then right, and Upshaw nearly trips over himself. The man snarls out a laugh and throws himself on

Upshaw, and as the two men roll onto the ground, Upshaw realizes the man isn't drunk at all. The man's face is shoved into his own, ugly as a turtle's, and now Upshaw sees that he's white.

This is for you and Plenty Coup, the man hisses, and a dark punching enters Upshaw's side, followed by a freezing pain. The man scrabbles off, panting. Upshaw sits up, watches as the man runs away. From the bar, Crow and white men have begun to tumble out on the street, and at the sight of Upshaw, the Crows start to shout. *I have to go home,* Upshaw thinks. *I have to tell Emma about this.* He straightens himself and the world turns swimmy and green. Dark cries erupt behind him. Men are shouting and hitting each other. Upshaw pushes himself to his feet. Around him, the snow on the ground is red.

My FATHER SITS by my mother's bed in the hospital, watching. What he'd said during the operation: *If she doesn't make it, I won't either.* My mother shifts in sleep. Her face emerges, degrades inside the light.

Curtis Studios, December 1909

When he receives the telephone call from Emma about Upshaw, Curtis doesn't speak. He stands in the dark front room of his studio, listening to her voice, awaiting some other information that will never come. Upshaw will always be gone now: Somewhere. Else. For a moment, he sees Upshaw's stubby fingers on the tent flap as he watches him prepare a glass plate. His hair has grown long in the last year. Over his plaid shirt: a necklace of abalone shells. *Where are you going now, where are you?* Curtis hangs up the telephone and turns on the light. His eyes. The light is hurting his eyes.

THREE SUBJECTS circling each other. Eros, identity, and elegy. A natural progression. In love with the newest mask, we strip each covering back to another version of the self. Then again. We mourn the loss of each one in passing.

Early morning in my parents' Paris apartment, street lights weakening the dark. My mother steps up, touches my father's face, enfolds him in her blanket.

I USED TO THINK that Curtis held his subjects captive to his project. And yet the reality is that we are each—artist and observed, father and child, husband and mother, or guide and wife—subjects. Each enthralled by what the camera can perform for us. Upshaw in the studio, touching the telegraphs the photographer has written to his family. *Word passes tribe to tribe. Tribes I won't reach for four or five years yet have sent word asking me to come to them—*

My mother two days before her surgery at her favorite restaurant, begging us to have a photo taken with her.

And of course, Curtis and Upshaw, my father and mother, are captives of mine. What do I know about their lives outside the vaguest summaries? Stories that I have, deliberately or inadvertently, gotten both wrong and right? To make the narrative seamless and, in its connections, beautiful. In this, I am no better, and no worse, than the photographer.

Is THIS THE SIGN of my ultimate assimilation? That I see what he sees? That I find the same things beautiful?

FOR ME TO ASSUME that Curtis only took advantage of his subjects is cynical. To criticize him for not taking authentic photos is to commit the same mistake he made in believing that there is an essential identity—a personality that's fixed, anachronistic, a truth that has simply been mis-captured, or not yet captured. Perhaps I should consider all photos as assimilations of true and false identities. All photos contain and convey change, even if the change can't be visually registered.

WHEN I TURN MY FACE one way I look like my father. When I turn my face the other way, my mother appears. Straight on, someone completely different slips into view. Each option both false and true. Whatever face I possess is in the turning, in the illusion and the fact that I get, continually, to choose.

WHAT DISTURBS ME MOST about his pictures
is that I adore them. Their sepias and blurry ochres. It is a
moment of intimacy to take the Curtis book from my father's
table, to imagine that I have seen what he sees in them, that
I might feel the way my father feels at the changing of his
world: the slow collapse of his idealism, my mother's illness—
something that reflects but does not always include us. If I see
what my father or mother sees, does that mean I come closer?
Or does it mean that I, too, become responsible for their
vision in ways from which I naively hoped I'd be released?

Intimate

With God's grace, the photographer says, and Upshaw turns into his pose. Wisp of mist coming off the mountain. Upshaw is all eyes, his full cheeks bright and moist, half-moons of shell strung on his bare breast. The wind makes the fine hairs along his arms and stomach rise. He has never been photographed so closely before, and he knows that there will be a faint line from his shirt around his neck and wrists, the outline of his other self like an echo of a ghost. Or perhaps that is his real self, even in this borrowed finery—a portrait of his own double exposure. Even as he averts his gaze, the large abalone shells on his chest still make him appear to be looking at the camera; he is both looking out and being looked at. The photographer watches. Upshaw could make anything he wanted out of himself here, and the photographer would recreate it, find whatever he most wants brought to life. He believes this, regardless of what he has seen. Here, at least, is a slim point of recognition between them, which is more and less than affection. Upshaw stands straighter, puts one arm out in front. The sun catches the half moons. He stares at the photographer till he has memorized his features: the lines

that concentration draws in his face, his rage, his focus. The man's pants have dark blue patches sewn at the knees. Fine blond hairs line the backs of his hands and wrists. A letter juts from a pocket. The man takes his picture. Upshaw takes his own picture back.

I LOOK AT the picture I've created in my mind. I look and look. The once firm face now sagging, hair dissolved from its scalp, chin lengthening, lines trenched under the eyes. I see the shirt worn at one end of the collar, a jacket covered in black and white stripes. Perhaps a cigarette burns in the left hand. And the light behind the head, cast to the side of the face, lengthens the shadows. I look and see the contradictions I have built into this body. Eyes alert but the shoulders crumpled. The knee upraised, but the hand propped there appearing wilted. New weight that pads the heavy breast and hips. The death-like skin, formerly olive, now fading and pale. The soft mouth. I look and look at this body and feel something like bewilderment at its possibilities, something more like love.

GO BACK. Look. Can you see them as I see them?

Snake Dance

He enters the kiva in a loincloth. Face and arms smeared with paint, cornmeal scattered on the water. He whips the snake with feathers till it straightens, stiffens, then he reaches down and grabs it by the neck. Diamondback, sidewinder, bull snake. Four days they combed the canyon until the earth broke apart to snake, the very rock alive, slick as muscle. Pink clay smeared over moccasins, corn smut and root juice. Until the very rock peeled back to blood and bone. He is all and each, elemental. Forked tongue, prayer water. His cheeks: black. His chin: white. Fringed belt of fox. *You have to give everything up,* says the priest. He slips the tail end of the rattler into his mouth. Snakes between his hands, around his shoulders. What is he but the thing he holds, a man in front and behind him, the women watching, earth itself slipping through his foot soles? Tossing each form aside to be given another. Scut of musk. Rain and river. He looks up. Another and another. The light is blinding here. The light is breaking him apart.

GO BACK. *What are you afraid of?* The body lying on its bed in the middle of the afternoon. Sweating. Sleepless. The whole body a fever of pain. *What are you afraid of?* To slip away from. To live in the process of death. To live already dead. Modernity rushing past, moving on, abandoning you. Now your family, too. Go back. *The light is terrible here. My eyes. I cannot open my eyes.*

What disappears? We do, of course.

The children called Curtis "Chief."

The Sioux called him "Pretty Butte."

The Crows called him "One Body Image Taker."

For Once

The sound of snakes hissing in the bag. The cool skin of it in his mouth, the whipping leanness, one coil of muscle turning across his tongue. He looks up: the heat, the dust, the sun, he can smell it, join it, for once, everything, yes, everything—

Harold Curtis, 1976

My father was the best man I ever knew.

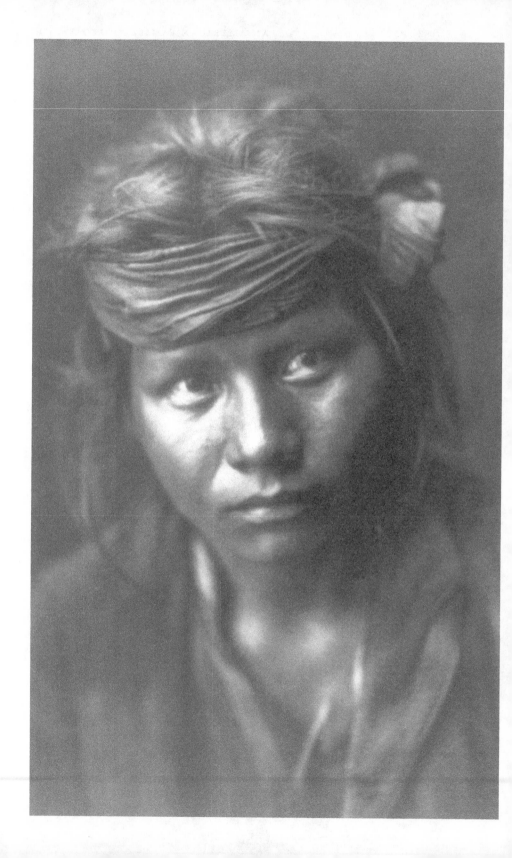

Edward Curtis's "Son of the Desert"

—Edward Curtis and Alexander Upshaw, 1905

We watched him come
 up the ridge all day,
the little Diné boy behind
 his herd of sheep, all day
across the undulating

 red, great masses
of cloud threatening
 hard, quick rain or
lightning, neither of which
 he could take cover from.

The sheep walked and grazed.
 We watched
the soft gray mouths tear
 at the silver grasses,
dark dirt quickly drying

 into red as the sheep
moved on, fine dust kicked up
 into the boy's face
as he smiled at us in passing,
 and I thought

of what the rancher told us,
 yesterday, that to truly
see the sheep was to forget
 our notions of it:
there is no sweetness

 to a hunger that must be
bottomless to keep itself alive.
 Something
the boy must know,
 who trails his herd

eight miles a day
 to find pasture
on land that shrinks
 and desiccates
from the herd's own need:

 the sheep reshape this land
the boy can never hope
 will be expanded for himself.
The boy must walk, the boy
 must feed what forever hungers,

 then stand, sickened,
alongside his father
 to watch him shoot
half these ewes according
 to federal conservation;

dead left to rot and blanch
 in the wash, too much flesh
to eat or sell.
 The boy walks.
He does not have a hat.

 He does not have a horse.
He carries his own food
 in a pocket
as he walks noiselessly
 through the wash,

looking so like the rancher
 in his sense of purpose,
the one we watched
 grab the struggling
back legs emerging from a sheep

and pull until we saw
the slick sack stream
 from her body,
followed by the next,
 the two lambs

steaming in the dust as the rancher
 tore the silver caul
of mucus from their mouths.
 When a ewe gives birth
to two lambs she chooses

 which to keep
by waiting. She watches
 until the first one stands,
then comes to it
 and begins licking,

roughing the blood up
 into the surface
of its skin.
 Sometimes a twin
dies. Sometimes

 the herder saves it,
and its cool marble eye trains
 ceaselessly upon him.
That day, the other lamb
 died. We watched

the ewe circle
 in her stone pen, rubbing
and rubbing there until the living
 lamb scrabbled up
to follow through the gate.

We watched
as it stumbled after
through the wash,
its strangely furrowed face
a knob of bone, a bit

of its mother's wool
still clinging to the stone.

PHOTOGRAPH SOURCES

Listings are given here in page order sequence:

2: "Before the White Man Came." Photograph by Edward S. Curtis.

8: "Goyathlay (Geronimo) and his family, circa 1985, at Fort Still, Oklahoma." Presented by Mrs. Allyn Capron, N37517. From *Spirit Capture: Photographs from the National Museum of the American Indian.* Johnson, Tim, editor. Smithsonian Institution Press, 1998.

29: "Little Six and Medicine Bottle on the Gallows, 1865." Photograph by Joel Emmons Whitney (1822–1886), in The Princeton Collections of Western Americana. From *The Photograph and the American Indian.* Bush, Alfred L. and Mitchell, Lee Clark, editors. Princeton University Press, 1994.

38: "Waiting in the Forest—Cheyenne." Photograph by Edward S. Curtis.

42: "Lewis and Clark's Landing Place at Nihhluidih." Photograph by Edward S. Curtis.

45: "Lenape (Delaware) man and son, 1906." Photograph by Mark R. Harrington, N3161. From *Spirit Capture: Photographs from the National Museum of the American Indian.* Johnson, Tim, editor. Smithsonian Institution Press, 1998.

50–51: "Chiricahua Apaches upon arrival at the Carlisle Indian School, Carlisle, Pennsylvania, from Fort Marion, Florida, November 4, 1886." Photograph by John N. Choate, in the General Nelson A. Miles Collection; presented by Major Sherman Miles and Mrs. Samuel Reber, P6848. From *Spirit Capture: Photographs from the National Museum of the American Indian.* Johnson, Tim, editor. Smithsonian Institution Press, 1998.

58–59: "Burial of the Dead at . . . Wounded Knee, South Dakota, 1891." Photograph by George R. Trager, N37900. From *Spirit Capture: Photographs from the National Museum of the American Indian.* Johnson, Tim, editor. Smithsonian Institution Press, 1998.

74–75: "Graduating Students, Carlisle Indian School (1897)," including Alexander Upshaw, third from left in middle row. Photograph by John Hiram Andrews. Courtesy of Archives and Special Collections, Dickinson College, Carlisle, Pennsylvania.

82: "Good Lance—Ogalala." Photograph by Edward S. Curtis.

86: "A. B. Upshaw, Interpreter Crows, 1898." Photograph by F. A. Rinehart. From *The Papers of Edward S. Curtis Relating to Custer's Last Battle,* Volume 2. Hutchins, James S., editor. Upton and Sons, n.d.

90–91: "Last family of potters and pipemakers, Pamunkey, Virginia, 1908." Photograph by Mark R. Harrington (1882–1971). Negative at The Museum of the American Indian, Heye Foundation, New York, New York. From *The Photograph and the American Indian.* Bush, Alfred L. and Mitchell, Lee Clark, editors. Princeton University Press, 1994.

92: "Indian Woman and child." Photograph by MacLean, in The Princeton Collections of Western Americana. From *The Photograph and the American Indian.* Bush, Alfred L. and Mitchell, Lee Clark, editors. Princeton University Press, 1994.

95: "Susan Jane Johnson, a Mohawk Wolf clanmother, with her son, Robert Harold Johnson. Six Nations Reserve, Ohsweken, Ontario, Canada." From *Spirit Capture: Photographs from the National Museum of the American Indian.* Johnson, Tim, editor. Smithsonian Institution Press, 1998.

98: "Vash Gon." Photograph by Edward S. Curtis.

102: "A. B. Upshaw, Interpreter Crows, 1898." Photograph by F. A. Rinehart. From *The Papers of Edward S. Curtis Relating to Custer's Last Battle,* Volume 2. Hutchins, James S., editor. Upton and Sons, n.d.

124–125: "At the Old Well of Acoma." Photograph by Edward S. Curtis.

132: "A Painted Tipi, Assiniboin" (bottom image), in the James Graybill collection. "A Painted Tipi, Assiniboin" (top image), in the National Geographic Society Collection. From *Edward S. Curtis: Coming to Light.* Makepeace, Anne, editor. National Geographic Society Press, 2001.

141: "Howard Tiger, first Seminole volunteer in the Marine Corps, displays his new uniform to his family at the Seminole Indian Agency, Fort Myers, Florida, 1942." Photograph from the *Miami Herald.* In the Archives of the Association on American Indian Affairs, The Princeton Collection of Western Americana. From *The Photograph and the American Indian.* Bush, Alfred L. and Mitchell, Lee Clark, editors. Princeton University Press, 1994.

154: "Jicaque man looking at a leica manual, 1938." Photograph by Victor Wolfgang von Hagan, P14768. From *Spirit Capture: Photographs from the National Museum of the American Indian.* Johnson, Tim, editor. Smithsonian Institution Press, 1998.

157: "Frances Densmore and Mountain Chief (Blackfeet) listening to a cylinder recording." Photograph by Harris and Ewing, Washington D.C., in the Charles Hoffman Collection, P19125. From *Spirit Capture: Photographs from the National Museum of the American Indian.* Johnson, Tim, editor. Smithsonian Institution Press, 1998.

162: "A Young Nez Perce." Photograph by Edward S. Curtis.

169: "Omaha Dance Bonnet and Scalp Lock, 1899." Photograph by Frank A. Rinehart. Courtesy of the Boston Public Library, Photograph #34. See http://www.footnote.com/document/234242081/.

171: "Navajo dancers entertaining a tourist train in Durango, Colorado, June 1863." Photograph by George Hight, N33190. From *Spirit Capture: Photographs from the National Museum of the American Indian.* Johnson, Tim, editor. Smithsonian Institution Press, 1998.

188: "The Potter Mixing Clay—Hopi 1921." Photograph by Edward S. Curtis.

194–195: "The Battle of Sobora: Mission Indian children at play." Photographic postcard, once in the collection of George Wharton James, now in The Princeton Collection of Western Americana. From *The Photograph and the American Indian.* Bush, Alfred L. and Mitchell, Lee Clark, editors. Princeton University Press, 1994.

207: "Pornography: A young Mojave couple." Photograph by Henry Buchman (1851–1912). In the collection of John H. Burkhalter III. From The Photograph and the American Indian. Bush, Alfred L. and Mitchell, Lee Clark, editors. Princeton University Press, 1994.

220: "A Family Group—Noatka." Photograph by Edward S. Curtis.

223: "The Rekdal family, circa 1971." Photographer unknown.

226: "Upshaw—Apsaroke." Photograph by Edward S. Curtis.

239: "Untitled, circa 1898." In the Lee Moorhouse Collection, M40, Umatilla County Historical Society, Pendleton, Oregon. From *Peoples of the Plateau: The Indian Photographs of Lee Moorhouse, 1898–1915.* Grafe, Steven L., editor. University of Oklahoma Press, 2005.

242: "Cook, a Sioux Brave and his daughter, Grace." Photographer by John N. Choate (1848–1902), in the Princeton Collection of Western Americana. Gift of Sheldon Jackson. From *The Photograph and the American Indian.* Bush, Alfred L. and Mitchell, Lee Clark, editors. Princeton University Press, 1994.

252: "Son of the Desert." Photograph by Edward S. Curtis.

ACKNOWLEDGMENTS

Thanks to the editors who published the poems in *Intimate*, including the journals *Blackbird, pistola magazine, Tin House,* and *Virginia Quarterly Review,* and the anthology *Satellite Convulsions: Poems from Tin House.* Thanks also to the Tanner Humanities Center, the Vice-President's Office for Research at the University of Utah, and the Utah Arts and Humanities Council for grants that specifically aided work on this book. And thank you to all the fine people at Tupelo for their brilliant insights and hard work on this—frankly, insane—project. Thanks particularly to editor Jim Schley and designer Josef Beery.